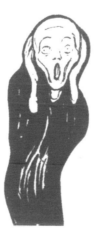

Ulrich Bischoff

EDVARD MUNCH

1863–1944

Images of Life and Death

TASCHEN

HONG KONG KÖLN LONDON LOS ANGELES MADRID PARIS TOKYO

To stay informed about upcoming TASCHEN titles,
please request our magazine at www.taschen.com/magazine or write to
TASCHEN America, 6671 Sunset Boulevard, Suite 1508,
USA–Los Angeles, CA 90028, contact-us@taschen.com, Fax: +1-323-463 4442.
We will be happy to send you a free copy of our magazine
which is filled with information about all of our books.

© 2007 TASCHEN GmbH
Hohenzollernring 53, D–50672 Köln
www.taschen.com
Original edition: © 1989 Benedikt Taschen Verlag GmbH
© VG Bild-Kunst, Bonn 1995 / The Munch Museum
The Munch-Ellingsen Group
English translation: Michael Hulse, Cologne
Edited and produced by Angelika Taschen, Cologne
Cover design: Catinka Keul, Angelika Taschen, Cologne
Editorial and biographical material: Marianne Faust, Ratingen

Printed in Germany
ISBN 978–3–8228–5971–1

Contents

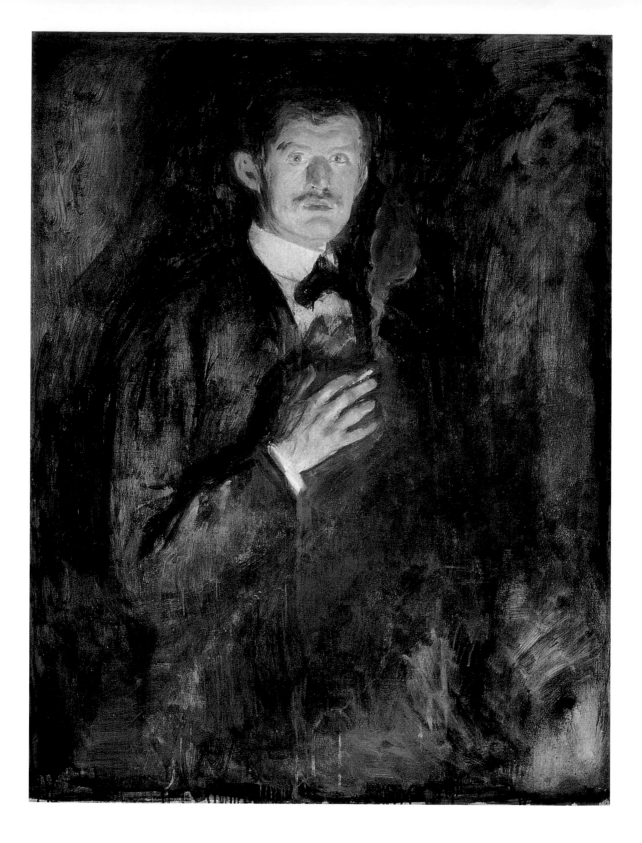

Munch's Artistic Background:

Christiania, Paris, Berlin

Those who go to Oslo and seek out the work of Edvard Munch will find that one of the clearest impressions they can gain of the Norwegian artist's work is a painting that was done in 1895, probably in Berlin, and which now hangs in the central room of the sky-lit gallery in the National Gallery. The painting is the *Self-Portrait with Burning Cigarette* (p. 6). A comparison of this work with the 1885 *Portrait of the Painter Gerhard Munthe* (p. 7), also in the National Gallery and done by Munch's teacher, Christian Krohg (1852–1925), is instructive. The comparison immediately makes clear how far Edvard Munch's artistic travels had already taken him, in just fifteen years, from his Norwegian beginnings.

Christian Krohg, eleven years Munch's senior, was arguably the major artistic force in Norway before the younger painter made his name. His significance in Scandinavia was comparable with that of Max Liebermann in Germany. Educated and trained in Karlsruhe and Berlin, Krohg subsequently became one of the leaders of Scandinavia's foremost artists' colony in Skagen, at the northern tip of Jutland. With the assistance of the painter Frits Thaulow, Krohg spent the winter of 1881–82 in Paris, where Edouard Manet's wonderful figure portraits made a particularly powerful impression on him – as they were to do on Munch a few years later. That Parisian sojourn resulted in portraits of colleagues and friends, painted in the years following 1882.

The portrait of Gerhard Munthe provides a particularly apt basis for comparison with Munch. The scene is a smoky café, suggested by small round tables where artists and literati are sitting. Krohg's fellow-artist and friend from student days Gerhard Munthe (1849–1929) is shown three-quarter length, wearing an elegant greyish black coat that stands out with subtly calculated emphasis against the brown colouring of the background. Krohg focusses on a precise presentation of the milieu and of this mildly arrogant artistic dandy. His painting and compositional techniques are subordinated to the naturalistic portrayal of an eccentric amidst the urbane atmosphere of everyday city life. Figurative clarity diminishes in the background, while the foregrounded section is

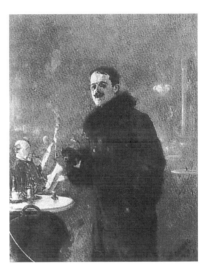

Christian Krohg:
Portrait of the Painter Gerhard Munthe,
1885
Oil on canvas, 150 × 115 cm
National Gallery, Oslo

LEFT:
Self-portrait with Burning Cigarette,
1895
Oil on canvas, 110.5 × 85.5 cm
National Gallery, Oslo

emphasized with a precision like that of a photograph. This approach, the hallmark of Impressionism, was marking its breakthrough in France, and subsequently spread from there throughout Europe and the USA.

Let us turn to Munch's self-portrait. At first we are struck by the similarities. We see a man in half-length, holding a burning cigarette, like Munthe. The cigarette smoke seems to be cloaking him in his own hazy atmospheric mood. But that is as far as we should go with similarities. If we look closely, we see that the differences are equally striking, and should give us pause. In Krohg's painting, the smoky ambience and the delicately held cigarette serve to indicate a social milieu. In Munch's, though, the blue smoke is used to heighten the expressive effect of the face and hand. In fact it almost acts as a frame for them, from the right sleeve to Munch's temples, and additional emphasis is provided by the stark white of the shirt cuff and the broad collar. A few thin streaks of red mark the nervy back of the hand, and there are clear traces of yellow on the right temple and that side of his forehead. The effect is to focus on the painter's penetrating gaze and his firm albeit nervous hand as the most important parts of the portrait. Munch's policy of abandoning localized colour and using prime colours of greater expressive power is clearly visible. Yet what is arguably more significant, and came to constitute an ever more basic, radical abdication, is the refusal to represent a realistic background. The space the painter's figure is seen emerging from is of unfathomable depth, and has been done using thinned oil paint hastily applied in patches, mainly red and blue. This contrast between the extreme precision of the face and the hand holding the cigarette (on the one hand) and the almost abstract quality of the setting (on the other) gives the painting a vivid immediacy. And naturally the contrast between the blue smoke-haze and the directness with which the painter is looking into the mirror has repeatedly prompted critics to interpret the picture in biographical or psychological terms. We need not take sides in their debates. We need only note that there is courage and resolution in the painter's stance, as if he were defying our scrutiny – of himself and of his work.

By the time he painted *Self-portrait with Burning Cigarette*, taking stock and taking his bearings for a first clearly apparent time, Munch had already travelled a sensational distance, and his route had taken him through scandal, hard work and misfortune. We need to know about his individual family situation and about conditions in the Norwegian capital (which was called Christiania until 1924). Illness and prudery were the powers that presided over Munch's artistic evolution and shaped the very essence of his vision. Sickness and death left a permanent mark on him in his childhood and youth, above all the death from tuberculosis of his fifteen-

Sister Inger, 1884
Oil on canvas, 97 × 67 cm
National Gallery, Oslo

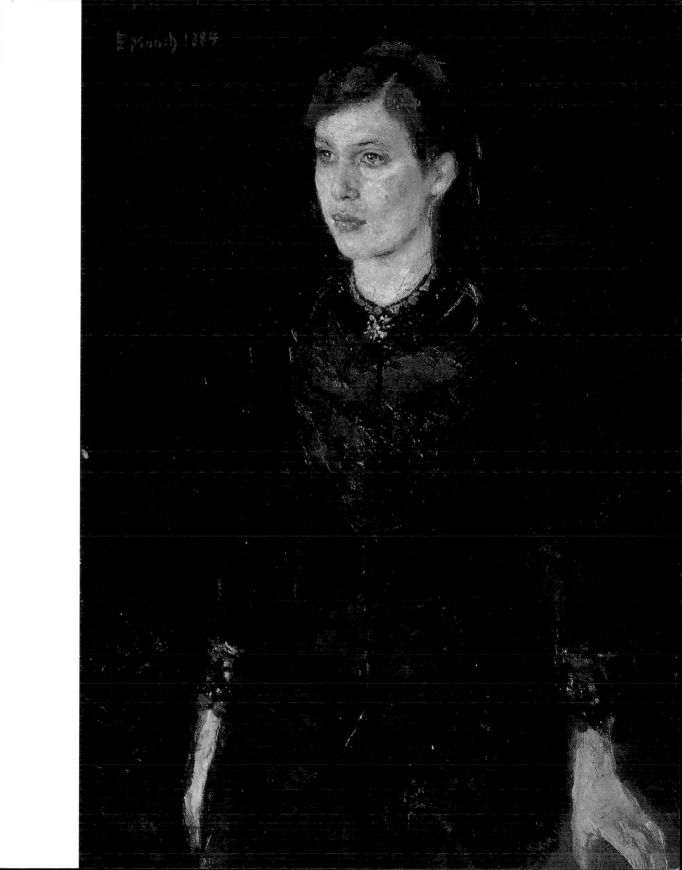

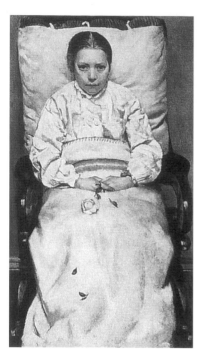

Christian Krohg:
The Sick Girl, 1880/81
Oil on canvas, 102 × 58 cm
National Gallery, Oslo

year-old sister Sophie. Edvard, fourteen at the time, was fully aware of the deadly course her illness was taking, and later gave artistic expression to Sophie's sufferings in *The Sick Child*. He had already lost his mother when he was five; she too had died of consumption, which was still extremely widespread a century ago. In 1889 Munch's father died while the artist was in Paris. Fear for his family's well-being and very existence was to haunt him into the 1890s. A comment he made later in life shows that Munch saw these factors as vital in his personal and artistic development: "Without fear and illness, my life would have been a boat without a rudder."

It is scarcely surprising, then, that Munch's earliest major work should have dealt with this subject. The version reproduced here (p. 11) is the first, dating from 1885/86. Describing it from the perspective of 1930, Munch later wrote to the director of the National Gallery in Oslo: "As for the sick child, it was the period I think of as the Age of the Pillow. A great many painters did pictures of sick children on their pillows." Two paintings of this kind are particularly worth mentioning: *The Sick Girl* (left) which Christian Krohg, whom Munch valued highly, painted in 1880/81 and which is also in the Oslo National Gallery now, and *Dying Child* (also there) by Hans Heyerdahl (1857–1913), a painter whose technique was perhaps even closer to Munch's. All three painters were drawing upon their own sisters' dying illnesses. The Swede Ernst Josephson (1852–1906) and the Dane Michael Ancher (1849–1927) were also pillow painters of the kind Munch writes of.

In Krohg's painting, the sick girl faces us frontally, sitting in a rocking chair, making a monumental impression. The white surfaces are given carefully realistic treatment, yet the square pillow that frames the head and the upper part of her body has a clear symbolic value. It is like a square halo, marking out one who has been declared a saint while still alive. The composition is reminiscent of some mediaeval formula to prompt an emotional response, with this "halo" complementing the roses (emblematic of transience, they are shedding petals) which she is holding in her clasped hands. Krohg has transformed his terminally ill sister, staring at us with wide-open eyes, into a memorial. Other versions of this kind of scene are contemplative naturalistic idylls in which the artist has focussed his skills on bouquets of flowers, prettily patterned blankets, or the gleam of light on medicine bottles.

Munch's *The Sick Child* is quite different. (In the 1890s he painted a new version of it. Indeed, there are several versions, as there are of all Munch's important paintings. He painted some of his pictures or motifs again and again throughout his entire life, *The Sick Child* is also familiar from the 1907 version that was in the Dresden gallery and found its way to London's Tate Gallery, via Oslo, in 1939.

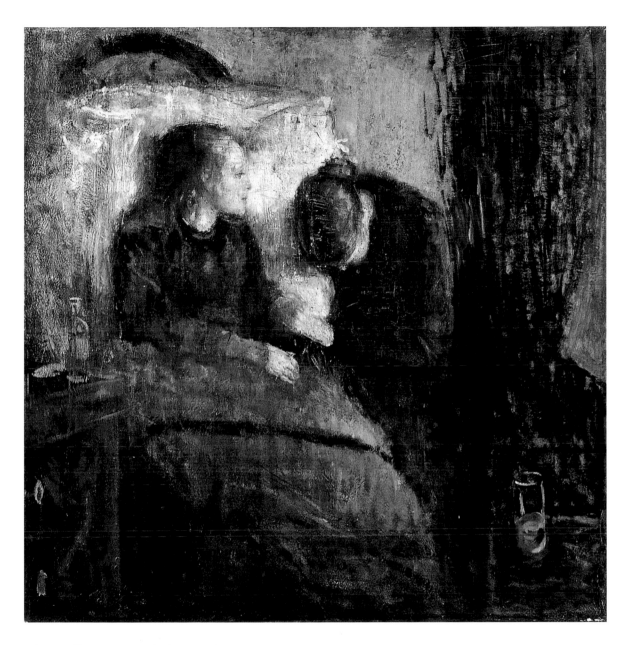

Above all, it was made famous by Munch's numerous graphic treatments.) It is difficult now to grasp why the painting should have provoked such violent and angry responses when it was first shown at the Christiania Autumn Exhibition in October 1886. The subject errs on the conventional side. The sick redhaired girl is sitting up in bed, propped on a fat pillow that supports her back. (Munch used Betzy Nielson, whose portrait he also painted, as his model in later versions.) She has turned to face the woman sitting or kneeling at her side, almost at her feet. The woman's head is bowed and we cannot

The Sick Child, 1885/86
Oil on canvas, 119.5 × 118.5 cm
National Gallery, Oslo

11

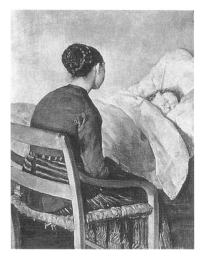

Christian Krohg:
The Mother at the Sick Child's
Bedside, 1884
Oil on canvas, 131 × 95 cm
National Gallery, Oslo

"I am convinced that there is hardly a
painter among them who drained his
subject to the very last bitter drop as I
did in *The Sick Child.* It was not only I
myself sitting there – it was all my lo-
ved ones . . ." EDVARD MUNCH

see her face. The cramped space is bounded at the left by a
bedside cupboard with a bottle on it, at back by a light wall
which the pillow seems to blend in with, and at the right by a
green area which is probably drawn curtains. In the fore-
ground right a half-empty glass of water is on a small table. In
other words, the composition could hardly have been the
principal cause of the fuss. The scandal, particularly in artis-
tic circles, was prompted by the artist's gall in exhibiting a
painting which foregrounded its own sketchy, roughwork
character. Munch himself called the work a "study". Thin-
ned-down paint, which he only started using as a deliberate
means of expression after 1900, is there on this canvas, as
Arne Eggum has shown. Deep grooves are scored in the layers
of paint and suggest intense, nervous work methods. And the
overall effect is not one of naturalistic physical presentation,
of detailed, anatomically accurate modelling using light and
shadow. Instead, this painting draws its power from within.
Indeed, the light in it is not falling on the figures and objects
from outside but is radiating from within the pillow and the
face of the sick girl (which has an almost transparent effect).
Numerous contemporary critics condemned Munch's ap-
proach as "incoherent daubs of paint", and one, describing
the girl's left hand (in the *Norwegian Intelligencer*, 25 Octo-
ber 1886), wrote ironically: "Surely that can't be a hand, can
it? It looks like fish stew in lobster sauce."

At the same exhibition, Munch exhibited *Sister Inger*
(p. 9). The portrait, somewhat less than life-size, was painted
in 1884, when Inger was sixteen, and is more traditional in
conception. This is particularly true of the model's stance
and clothing; Inger is seen wearing her black confirmation
outfit. The painting was included in a show of Norwegian art
at the Antwerp world fair in 1885, but back home it was
nevertheless given a rocky reception. Newspaper art critics
poured on this work the terms of abuse they normally re-
served for the French feminist Louise Michel, or simply dis-
missed it as ugly: "his appallingly ugly portrait of a lady in
black". If we read the contemporary notices, and especially
the violent rejection of this portrait, it is difficult not to con-
clude that the establishment press was aiming to strike a
blow against the whole of Christiania's Bohemia through its
attacks on Munch.

The narrow-mindedness, complacency and hypocrisy of
middle-class society constituted the backdrop in almost
every play by Henrik Ibsen (1828–1906), the most important
of all Norwegian dramatists. And Ibsen neatly burlesques the
inflexibility of that way of life in *Peer Gynt* (1867), when the
Old Man describes the code of the trolls: "Troll, to thyself be
– *enough.*" The provocative efforts of Scandinavia's artistic
Bohemians were targeted solidly against middle-class com-
placency and unbending ethical, moral and religious princi-

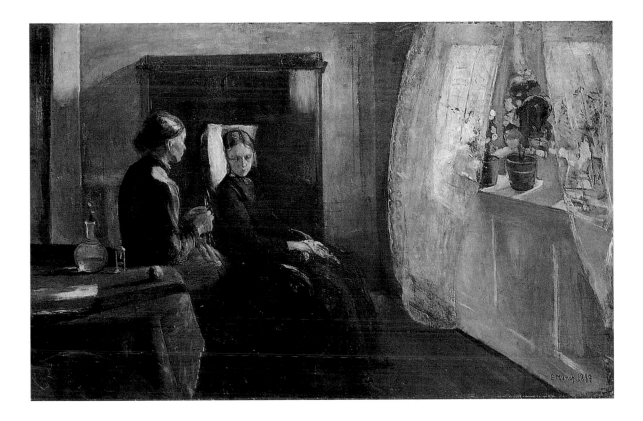

Spring, 1889
Oil on canvas, 169 × 263.5 cm
National Gallery, Oslo

ples. The author Hans Jaeger (1854–1910) was considered the head of the literary Bohemians, and Christian Krohg became the painters' foremost advocate of the "free life". Jaeger's novel *Fra Kristiania Bohêmen* (*Christiania's Bohemia*) was confiscated on publication in 1885, Jaeger himself was repeatedly imprisoned on account of his inflammatory writings. In addition to the portrait of Jaeger which he painted in 1889 and which is now in the Oslo National Gallery, Munch planned an entire cycle on the life of the Bohemian. As for painter and writer Christian Krohg, his large-format painting *Albertine* occupies a similar position in his work to that of *Fra Kristiania Bohêmen* in Jaeger's. It depicts a scene from his 1885 novella of the same title, which deals with prostitution and the middle-class world that supports it. Krohg's book was also confiscated as soon as it was published. Scandinavian literati who were familiar with Paris and Berlin (among them Georg Brandes, one of the best-known advocates of societal reform and progress) exerted a growing influence on Christiania's Bohemia.

The Swedish art historian J. P. Hodin (author of *Edvard Munch, Genius of the North*), has described Jaeger's circle in these terms: "Christiania's Bohemians were all for individualism, and campaigned against society's hypocritical moral

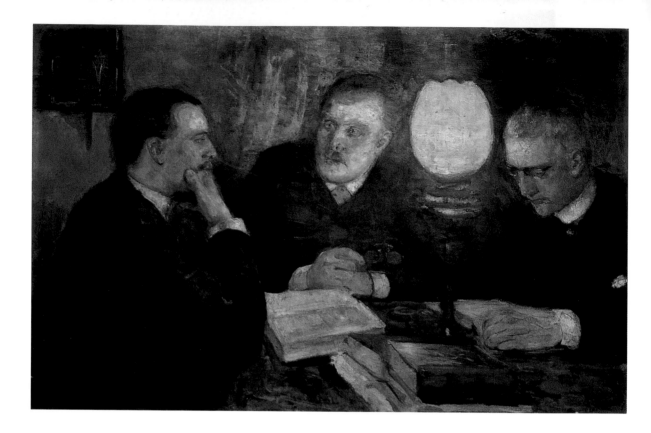

Jurisprudence, 1887
Oil on canvas, 81.5 × 125.5 cm
National Gallery, Oslo

RIGHT:
Portrait of the Painter Jensen-Hjell, 1885
Oil on canvas, 190 × 100 cm
National Gallery, Oslo

code. They called for social and intellectual liberation, subjected prevailing values to careful critical scrutiny, and aimed to put into practice their ideal of a better social code, a code of greater vitality and honesty. Christiania, wholly in the grip of rigid conventions, must surely have been unparalleled in the vehemence with which the struggle for these new ideas was conducted in the 1880s."

At the same time, Frits Thaulow was passing on to a group of young painters the *plein air* techniques he had learnt in Paris. Munch adopted their total rejection of academic modelling and meticulous underpainting in portraiture, and his approach is quite plain in his life-size full-length of the painter Karl Jensen-Hjell (1862–1888), done in 1885 (p. 15).

In 1887 Munch painted *Jurisprudence* (p. 14), which shows three young law students seated round a table, immersed in books and talk. Bernt Anker Hambro (1862–1889) in the middle and Johan Michelsen (dates unknown) were committed socialists who are known to have taken part in a socialist demonstration on Norway's National Day. The third, called Knudson, was no doubt also one of Christiania's Bohemian intellectuals. The picture was shown at the 1887 Autumn Exhibition in Christiania, together with five other works by Munch, and (as was to be expected after the abuse

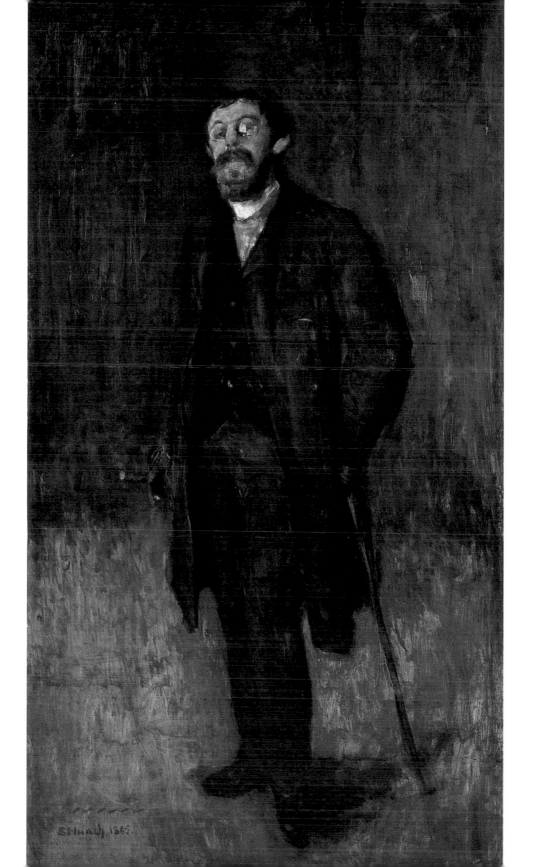

Inger Munch, 1882
Charcoal, 34.3 × 26 cm
Munch Museum, Oslo

Munch's art had attracted the year before) it came in for a good deal of ironic disrespect from the critics. The *Morning Post* wrote: "In *Jurisprudence* he presents us with a tragicomic situation. Three young men are sitting at a table, absorbed in a difficult legal problem. The man in the middle seems unequal to the mental demands that are being made on him; his fixed, vacant gaze suggests that his state of mind may be in jeopardy. Perhaps the picture is warning us against studying law, since there are too many lawyers as it is."

1889 is rightly seen as a decisive year in Munch's career. It began with serious illness, and while he was convalescing he painted *Spring* (p. 13). The picture was strongly autobiographical in flavour, combining memories of his sister's illness with the recovery of his own strength. It also provided a demonstration of his artistic skill that paved the way for a state scholarship that paid for a longer sojourn in Paris. At that point in his career, the canvas was unusually large for Munch; and he filled it with the entire repertoire of naturalistic interior effects. Once again a sick girl is at the centre, framed by a white pillow and the big brown cupboard behind her. The girl's face is extremely pale, and contrasts eloquently with the healthy ruddiness of the elder woman (her mother) sitting in profile beside her. The glass carafe and medicine bottle on the dark table bear mute witness to the course of an illness, and establish a vivid emblematic antithesis to the brightness and life represented by the daylight flooding in at the window where plantpots stand on the sill. The curtains are waving in the breeze entering at the window, and the invigorating quality of fresh air contrasts with the dark and heavy atmosphere of the sickroom. It is Munch's most important painting of this period. If he had not evolved his own personal iconography in which the image of the sick child played so vital a part, we might be tempted to see this work in a programmatic light. It shows Naturalism – with its obsessive love of detail, its insistence on precision, and its tendency to almost photographic reproduction of the textures of life – meeting the vividness and vitality of Impressionism. It is a meeting of the greys and browns of the left-hand side of the picture with the bright and airy *plein air* painting of the right-hand side (a manner which was the international hallmark of Impressionism). It is especially tempting to interpret the painting in this way if we bear in mind that the young artist, so often attacked by the critics, needed to win the respect of the jury who could approve his scholarship and thus make it possible for him to work in Paris.

Basically, then, *Spring* is almost academic in approach. But *Summer Night (Inger on the Shore)* (p. 17), painted that summer in Åsgårdstrand, shows we should not draw hasty conclusions. Five years before, he had painted his younger sister Inger wearing her black confirmation outfit in a tho-

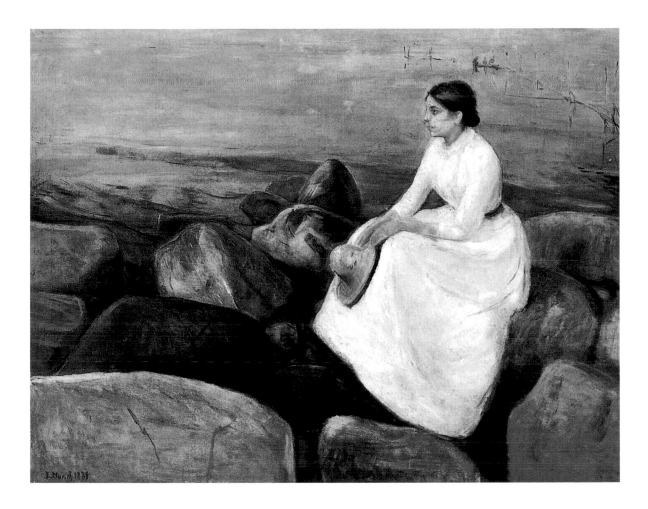

roughly traditional 19th century style. Now, in *Summer Night*, he took his place in the new European art of the late 19th century and took a decisive step forward into the new century ahead. We see a young woman (Inger) dressed in white and seated in profile on a massive granite boulder. There is a suggestion of human activity in the top right, behind her back, where we see a fishing-boat and the poles that mark out fish-traps. Otherwise, the setting is a simple natural landscape devoid of Man. The painting's structural components are the mossy, greenish boulders, the bright dress, and the shimmering bluish-red expanse of water. The intense yet indirect light of a northern summer and the young woman's tranquillity are nicely harmonized. We are struck by the delicacy of the colour tones, largely a result of the juxtaposition of red and blue shades. The light and the colours, the figure and the setting, all blend into a new overall impression. Munch once said: "I do not paint what I see, I paint what I have seen." In *Summer Night*, a momentary scene has been

Summer Night (Inger on the Shore), 1889
Oil on canvas, 126.5 × 162 cm
Rasmus Meyer Collection, Bergen

recalled from memory and refashioned in paint, and through the creative act it has become an image of human existence. This early work contains the whole essence of Munch's art, if we will but attend. In compositional terms it shows his reliance on horizontal and vertical axes. In thematic terms it illustrates his preoccupation with loneliness, sadness, and existential *angst* – which were to be central subjects of his Frieze of Life.

Needless to say, the critics disliked the painting. When it was exhibited in October 1889 they spoke of "stones absently tossed down from some soft, amorphous mass" and interpreted the picture as "a mockery of the public". Alongside the antagonistic condemnation, however, Munch did receive some approval, too. As so often in questions of art, it came from fellow-artists. One of them was Erik Werenskiold (1855–1939), a member of the Fleskum colony, a group of Norwegian painters. The Fleskum colony aimed to establish *plein air* painting in Norway, and thus create a new national art that would link the Norwegian landscape to a sense of national identity. Werenskiold saw *Summer Night* at the Christiania Autumn Exhibition and promptly bought it.

While the press and the public (on the one hand) were adamantly continuing to reject his art, and his fellow-artist Werenskiold (on the other) was buying the work they so violently detested, Munch had arrived in Paris and was setting about coming to grips with the important French art of the day. He started studies at Léon Bonnat's art school. Of greater significance, though, were his visits to the major Paris exhibitions, where he was able to make first-hand acquaintance with paintings by Van Gogh, Toulouse-Lautrec, Monet, Pissarro, Manet and Whistler. *Night in St. Cloud* (p. 19) may have been inspired by James Abbott McNeill Whistler's *Nocturnes*, which had been prompted partly by the London fog and partly by the haze on the Venice lagoon. Unlike Whistler, though, Munch does not dissolve his pictorial space in the mist, but prefers a structure based on a firm linear design. The small room is divided up by vertical and diagonal axes, and although it is a confined space in reality they create an impression of greater, ampler space.

It is generally agreed that the man in the far corner wearing the top hat is Munch's Danish friend, the poet Emanuel Goldstein. Munch and Goldstein had moved out to the picturesque Paris suburb of St. Cloud to escape a cholera epidemic. But if the figure is Goldstein, it is also Munch himself, in a sense: Munch the melancholic, that is, who is aware that death (symbolized by the double cross of the window) is always present. In *The Sick Child* (p. 11) and *Self-portrait with Burning Cigarette* (p. 6) Munch's spatial sense rendered the interior as a prison. In those paintings, we see the figures in glass cages that have been smeared with streaks (in *The Sick*

Night in St. Cloud, 1890
Oil on canvas, 64.5 × 54 cm
National Gallery, Oslo

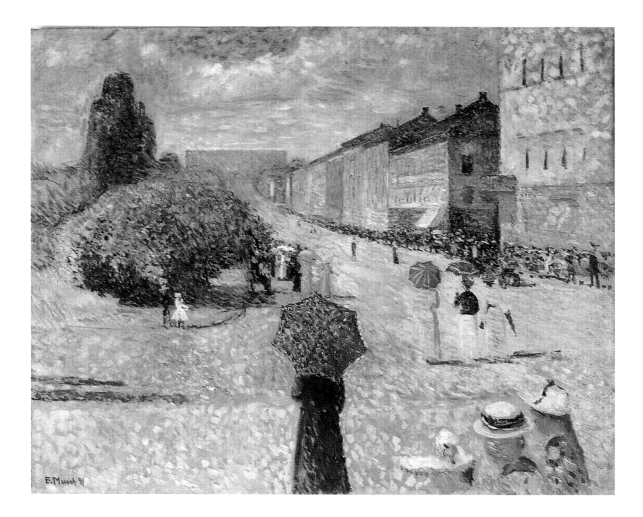

Spring Day on Karl Johan, 1890
Oil on canvas, 80 × 100 cm
Billedgalleri, Bergen

RIGHT:
Rue Lafayette, 1891
Oil on canvas, 92 × 73 cm
National Gallery, Oslo

Child they are scratched score-marks). In this one, Munch's little room above a St. Cloud café has been transformed into a showcase where we witness all the confinement of human existence.

In two works painted shortly after *Night in St. Cloud* a quite different Munch seems to be at work. *Spring Day on Karl Johan* (p. 20), painted in 1890 during a brief visit to Norway, is clearly influenced by the Impressionists, as is *Rue Lafayette* (p. 21), done in 1891 when Munch was back in Paris. Both pictures are flooded with light, an effect created by a rain of colour consisting of dabs or loosely applied parallel streaks of paint. Stylistically, then, they are thoroughly Impressionist in character. However, their composition – the structure underlying the shimmering surfaces – is by no means Impressionist. The earlier of the paintings shows Karl Johan Street, Christiania's major thoroughfare and promenade for the middle class, from the Grand Hotel at the right to

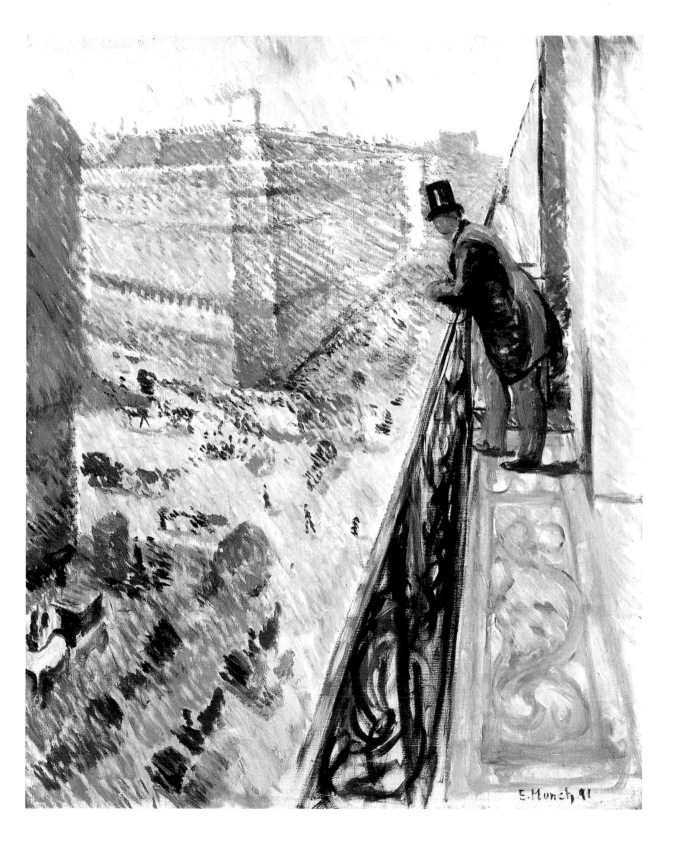

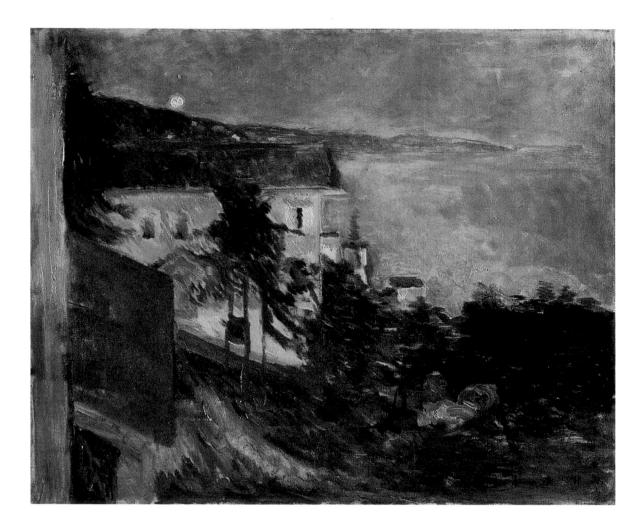

Moonlight over Oslo Fjord, 1891
Oil on canvas, 59.4 × 73.3 cm
Rasmus Meyer Collection, Bergen

RIGHT:
Girl combing her hair, 1892
Oil on canvas, 91.4 × 72.3 cm
Rasmus Meyer Collection, Bergen

where the castle bars the way in the background. We are
struck by the dominant blue tones, which make a line of the
roofs and also, parallel to that line, link the people out walk-
ing on the street into a second line that runs deep into the
picture. A female figure with her back to use is contrapun-
tally positioned in the centre of the painting. The red and
blue contrast of this figure sets her apart from the atmosphere
of the scene as a whole. Munch establishes a balance between
firm structures with a symbolic quality (the figure viewed
from the rear, the lines receding into the depths) and light-
hearted genre painting (as in the three children wearing yel-
low straw hats who are seen entering the sunny square at the
bottom right as if they were strolling into the foreground of a
snapshot).

After a spell in Nice, convalescing from a bout of rheu-
matic fever, Munch returned to Paris and took a little room at
49, Rue Lafayette. There, in May 1891, Munch painted the

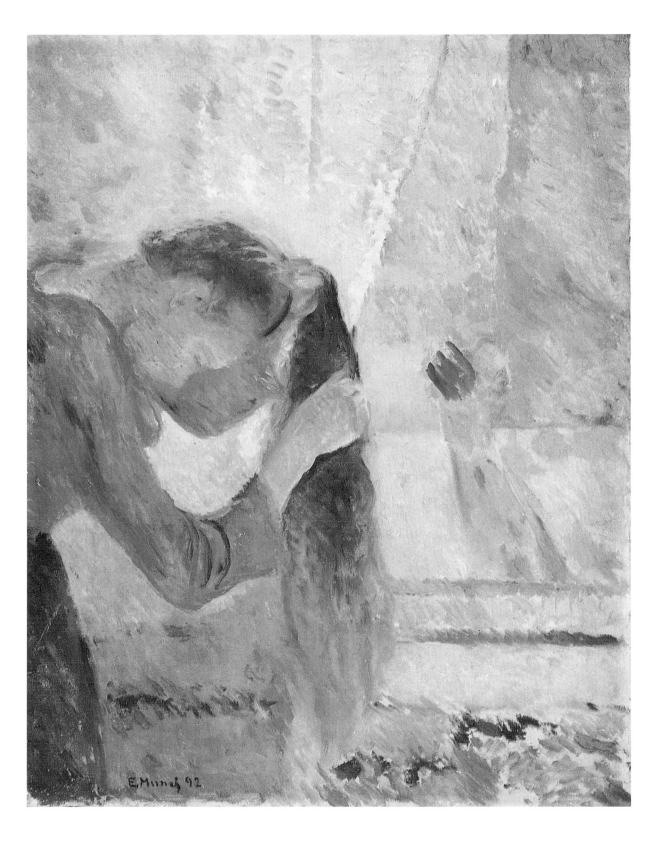

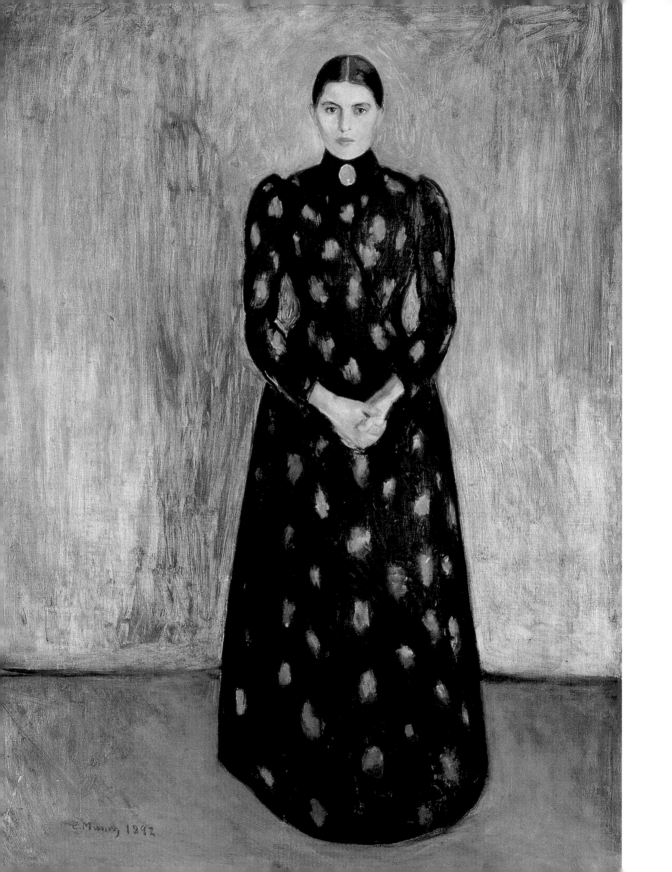

second of our two works, *Rue Lafayette* (p. 21). It is one of those paintings which Munch himself retrospectively referred to as "a brief revival of my Impressionist period". It probably shows the view from Munch's room, and draws our gaze along the balcony's diagonals deep into the street below. The street looks busy. On closer inspection, though, the everyday bustle proves to be nothing but loosely-applied streaks of paint. The man on the balcony is viewing the scene with a flaneur's appraisal; in a sense he represents ourselves as we look at the picture. It is a configuration that is typical of Munch and appears in some of the Frieze of Life works. Kirk Varnedoe, Director of the Museum of Modern Art in New York, acutely suggested in 1976 that Munch owed a debt to the French painter Gustave Caillebotte (1848–94). The motif of looking from a balcony down on one of the Haussmann boulevards recurs in another of Munch's paintings of 1891, *Rue de Rivoli* (now in the Fogg Art Museum, Cambridge, Massachusetts), where the diagonal drags our gaze into the depths with dizzying, dramatic speed. *Rue de Rivoli* is even brighter than the Oslo painting, and shares this brightness with a number of other works done at the same time in Paris, of which *Girl combing her hair* (p. 23) is characteristic. It was painted in 1892 and is now in the Rasmus Meyer Collection in Bergen. Taken together, these paintings constitute an island of tranquillity in the vast and alarming turbulence of Munch's work in general at that period.

At the end of October 1892, Munch travelled to Berlin, taking his paintings with him. There were now a respectable number of them; apart from *The Sick Child, Spring, Rue Lafayette* and the others we have mentioned, there were also some of the major pieces from the Frieze of Life, to which we shall turn in the next chapter. Munch's first brush with Germany was marred by a scandal that did nothing to help the unprejudiced reception and understanding of his art. It all started with a recommendation which the Norwegian Adelsten Normann had chanced to make. Normann was the director of Berlin's conservative Artists' Association, and at his suggestion they invited the young Norwegian painter Edvard Munch (then unknown in Germany) to exhibit. They had just opened new exhibition premises at 92, Wilhelmstrasse, and Munch's was to be the first solo show. Munch took great care over hanging the fifty-five paintings. The exhibition opened on 5 November 1892, prompted a howl of outrage from the entire press of Berlin, and closed again a week later. There had been heated debate in the Association on the question of spurning a foreign guest whom one had, after all, invited; but the decision was never really in doubt. The contemptuous dismissal Munch's work encountered at that time can also be seen in the fact that the press did not even get his name right. One paper referred to "the Christiania painter E. Blunch".

Sister Inger, 1892
Oil on canvas, 172 × 122.5 cm
National Gallery, Oslo

PAGE 26:
Paris Nude, 1896
Oil on canvas, 80.5 × 60.5 cm
National Gallery, Oslo

PAGE 27:
Nude, 1896
Oil on wood, 65 × 49.5 cm
Rasmus Meyer Collection, Bergen

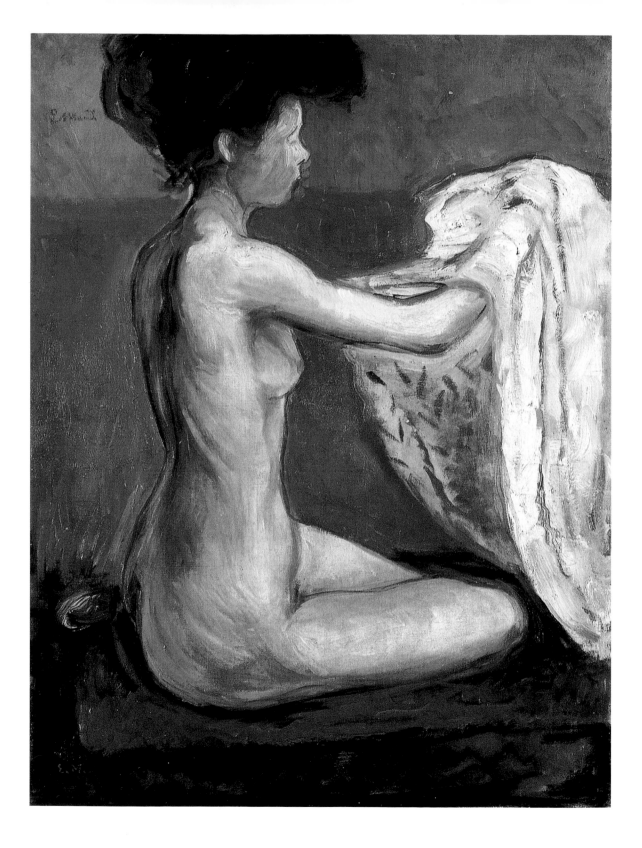

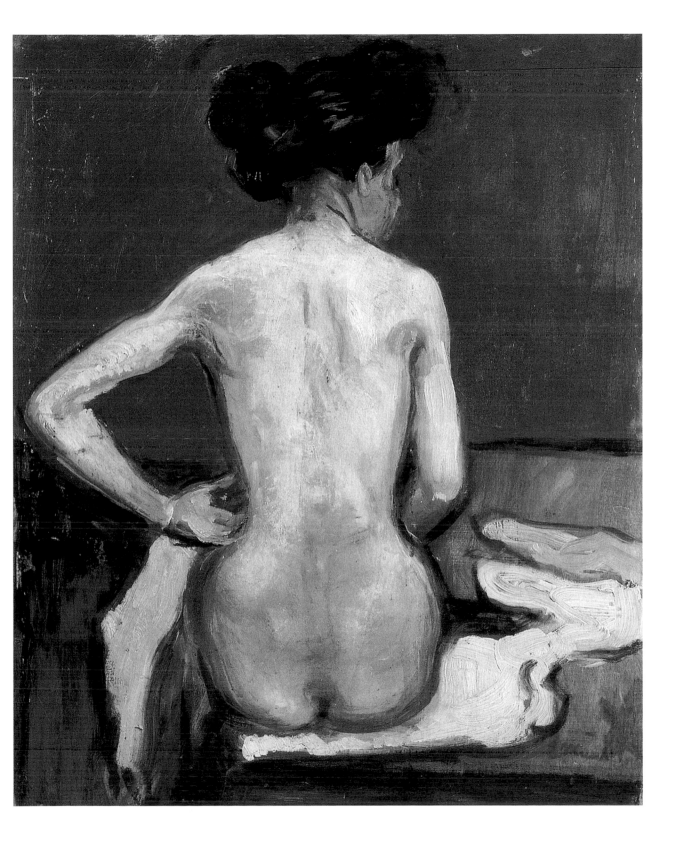

"He paints things, or rather he sees them, differently from other artists. He only sees what is essential, and needless to say that is all he paints, too. That is why Munch's pictures are generally 'unfinished', as people are so fond of noting. But they are finished, they are – they are his own finished work. Art is finished once the artist has truly said everything that was in his heart..."
CHRISTIAN KROHG

Adolf Rosenberg, an influential German critic, attacked Munch in terms that can still be heard in our own time: "these portraits are so sloppily daubed that at times it is difficult to identify them as human figures. [...] There is nothing more to be said about Munch's pictures, since they have no connection whatsoever with Art." Legend has it that this raucous brouhaha prompted the younger artists to take Munch's side, but the fact of the matter is that scarcely any of the artists in Berlin lifted a finger on his behalf. It is true that those who went on to found the Berlin Sezession protested against Munch's treatment; but they did not express opinions on his art.

The exceptions were the painter Walter Leistikow and the literati who met at a wine bar called Zum schwarzen Ferkel (The Black Piglet). This circle consisted mainly of German and Scandinavian writers, but the Pole Stanislaw Przybyszewski (who wrote in German) was also a member, and later described the bar and its clientèle in his *Memoirs of literary Berlin*. Türke's wine bar was apparently rechristened The Black Piglet by August Strindberg, who found the wineskins reminded him of pigs. Munch became a regular while he was in Berlin. As so often in the art world, the initial scandal had awoken interest in Munch and his paintings. The exhibition, closed down by Anton von Werner and his associates, toured to Cologne and Düsseldorf and by December 1892 was back in Berlin, thanks to the efforts of Schulte the art dealer. It went on show in premises Munch had hired out of his own pocket. For the next year or so, Berlin was to be his home from home – and for the first time he was selling enough paintings to scrape a living together.

In June and September 1895 and spring 1896, Munch was once again in Paris, painting a number of oil sketches. These works will seem of greater consequence if we bear in mind that Munch – along with Henri de Toulouse-Lautrec – was the originator of the oil sketch that stood as a finished work. Some were done on paper and others on joiners' boards glued together; the cracks and joins in the boards were not filled in, nor was the surface primed, but the artist (and, much later, the art community) viewed these works as finished products, as much so as his other paintings. The three pictures of Paris models reproduced here (pp. 26, 27 and 29) remind us that Munch followed the parisian art scene carefully (Pierre Bonnard, Toulouse-Lautrec, Edouard Vuillard). From here it was only a short step to his full majority as an artist, that masterly conception that stands at the heart of his work: the Frieze of Life.

RIGHT:
Girl washing, 1896
Oil on wood, 74.5 × 59 cm
National Gallery, Oslo

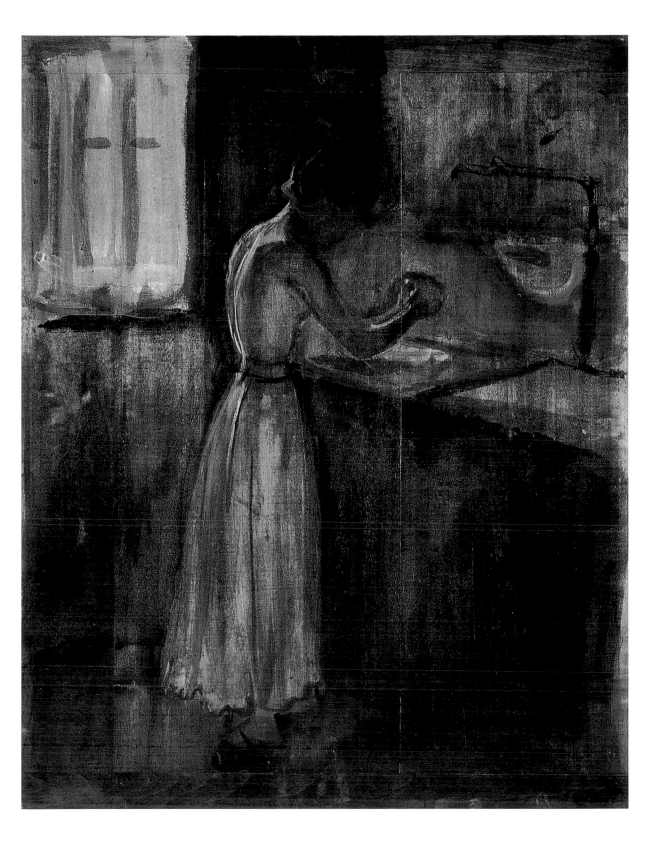

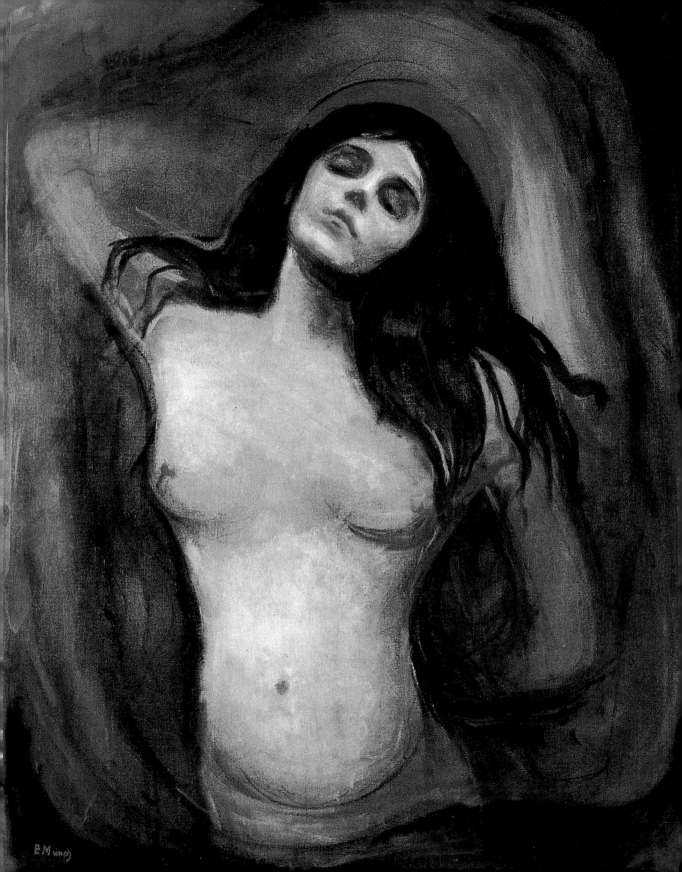

The Frieze of Life:

"A poem of life, love and death"

The scope and ambition of Munch's life's work is so vast that to grasp it we are well advised to think in literary terms. Untiringly he attempted to paint a work that would include every aspect of human existence: the Frieze of Life. It is a conception that recalls encyclopaedic writings of the late Middle Ages, or the work of Shakespeare, Herman Melville, Gustave Flaubert or James Joyce.

His first efforts dated from 1886, the year of *The Sick Child* (p. 11) and the lost early versions of *Puberty* and *The Day After*. He put Naturalism behind him in Christiania, Impressionism in Paris, and Symbolism in Berlin. And only then was the way clear for his new formal language. It was a language that was far better able to formulate the painter's quest for apt expression than any available approaches were. Its special qualities become plain if we compare the settings Munch chose (Karl Johan Street in Christiania, Åsgårdstrand in the Oslo fjord, Skøyen, Hvitsten or Nordstrand) with what he made of them in his art.

Åsgårdstrand was Munch's main stage for his drama of life. Some fifty miles south-west of Oslo, it is a water resort and fishing town. As a human settlement its history stretches a long way back. It is situated on a broad bay with a view across the fjord, and the pine forests reach to the shore. In the old days there was a long and solidly-built mole where the steamers from Christiania would make fast. It is a pleasant place for bathing, with a seaside character, yet protected from the worst storms by its fjord position, basking in the northern sunshine; and even before Munch's time it was popular among painters. With the slopes rising gently from the shore-line, the village character of the township, and the delightful woods, Åsgårdstrand remains essentially unchanged to this day. When Munch first visited in autumn 1888 he met two fellow-painters there, Christian Krohg and Hans Heyerdahl. In summer 1889 Munch rented a little fisherman's cottage that was standing empty, and in due course bought it (1897).

Following the previous year's scandal, Munch exhibited a new selection of paintings in Berlin in December 1893. An Åsgårdstrand picture now in the Boston Museum of Fine Arts

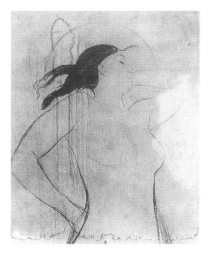

Study for *Madonna***, 1893/94**
Charcoal on paper, 73.8 × 59.8 cm
Munch Museum, Oslo

LEFT:
Madonna, 1894/95
Oil on canvas, 91 × 70.5 cm
National Gallery, Oslo

The Voice, 1893
Oil on canvas, 87.5 × 108 cm
Museum of Fine Arts, Boston

entitled *The Voice* (p. 32) appeared as the first in a series of six paintings which later became the heart of the Frieze of Life under the title *Love*. But let us begin our discussion of the Frieze of Life by looking at another picture related in subject, *Moonlight* (p. 33), done in 1895 and now in the Oslo National Gallery. True, the later work lacks the figure of the young woman facing us from the left foreground. What it does show with great clarity, however, is the central importance of the column of moonlight. We need not be experts in psychology to recognize that Munch's recurrent images – the water and the column of moonlight, the treetrunks that divide up the canvas vertically and the gentle horizontals of his shorelines – are symbols of male and female. Landscape in Munch acquires tensions, and the individual forms are invested with their own characteristics and evolve a new pictorial idiom of their own. In his treatment of the woods and shore at

Åsgårdstrand we are struck by a simplified and monumental quality in the conception, the geometrical approach to the composition as a whole, and the formulaic reductiveness of his treatment of Nature. Pine branches become triangular shapes like sails. The moon's reflection is a test tube shape on the water. The fluid, ill-defined use of paint (which is particularly apparent where the water meets the land) is countered by the absence of perspectival foreshortening and by the stark severity of the treetrunks rising parallel to the picture's vertical edge. The suggestive content (moon, water, etc.), the tender application of paint, and the meeting of bright light and dark shadow, give this work clarity and emphasis. It has these strengths in spite of the medium format; and indeed it is easy to imagine works such as this transferred to the monumental proportions of the murals Munch created twenty years later for the Aula (Great Hall) of Oslo University.

Moonlight, 1895
Oil on canvas, 93 × 110 cm
National Gallery, Oslo

Puberty, 1894
Oil on canvas, 151.5 × 110 cm
National Gallery, Oslo

The public viewed Munch as a wild dauber. And they took it as a defiant challenge when his subjects seemed forever to be going beyond the bounds of good taste and morality. It is hardly surprising, then, that Munch should have adopted the view that his paintings would be more accessible if they were considered in series rather than as individual works. "These paintings are rather hard to understand, but I think it will be easier if they are seen in context – they deal with love and death." In 1902 the Berlin Sezession gallery exhibited Munch's Frieze of Life pictures in systematic sequence for the first time (followed by a Leipzig gallery in 1903). The pictures were hung on four walls, which prompted Munch to divide them under four thematic heads; 'Love's awakening', 'Love blossoms and dies', 'Fear of life', and 'Death'.

Puberty (p. 35), finished in 1895, was not on display. But that painting (and the lost earlier version of 1886) makes a cogent forerunner of the 'Love's awakening' series. We see a young, pubescent girl sitting naked in a confined setting. The composition is based on a horizontal (the bed, cropped by the edges at left and right) and a vertical (the girl sitting on the bed). Light is falling from the left, casting a large, dark shadow that serves to heighten the frail, precarious exposure of the naked girl. At the time the picture was painted, works showing girls who were acting as models for the first time were greatly in vogue, and they generally had a lewd air of suggestiveness about them; but both the ominous shadow and the sense of tender frailness rule out interpretation of Munch's painting in these terms.

The artist had already written a compelling account of the phenomenon of shadow in his St. Cloud manifesto (notes written in Paris in spring 1890): "...I go out walking in the moonlight – where the old stone statues stand, overgrown with moss – I by now am familiar with every one of them – and I am frightened by my own shadow... When I have lit the lamp I suddenly see my own enormous shadow convering half the wall and reaching to the ceiling – And in the big mirror over the stove I see myself – my own ghostly face – And I lead my life in the company of the dead – my mother, my sister, my grandfather and my father – with him above all – All my memories, the smallest of details, return to me..."

In this passage, shadow is expressive of the remembered past and of the deaths Munch had experienced in his own family; in *Puberty*, the dark, outsize shadow of the girl's body suggests the menace of the future that lies beyond her youthful years. Puberty is that difficult phase of transition from childhood to adulthood. In Munch's girl we perceive both awakening sexuality and a sense of being at the mercy of the Unknown; we see this in her wide-open eyes, and in the crossing of her arms over the pubic region (in terms of body language, this position speaks volumes). For the first time we

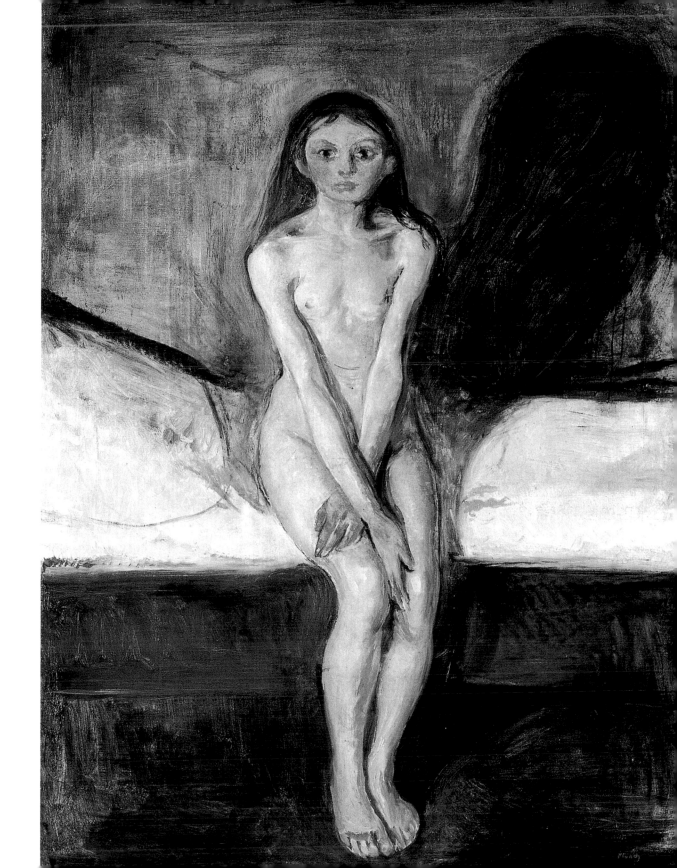

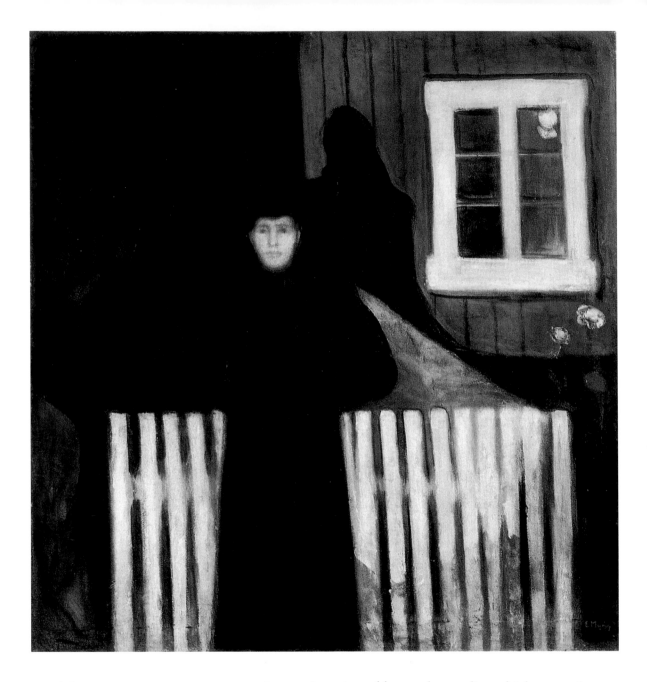

Moonlight, 1893
Oil on canvas, 140.5 × 135 cm
National Gallery, Oslo

see that conjunction of fear and sexuality which was to become central in the Frieze of Life.

In *The Sick Child* (p. 11) and *Night in Saint-Cloud* (p. 19), Munch's people had seemed prisoners in their interiors; and in an 1893 painting now in the Oslo National Gallery, the almost perfectly square *Moonlight* (p. 36), we see a young woman confined at the near edge of the picture by a fence and the wooden house behind it. She is seen almost full length

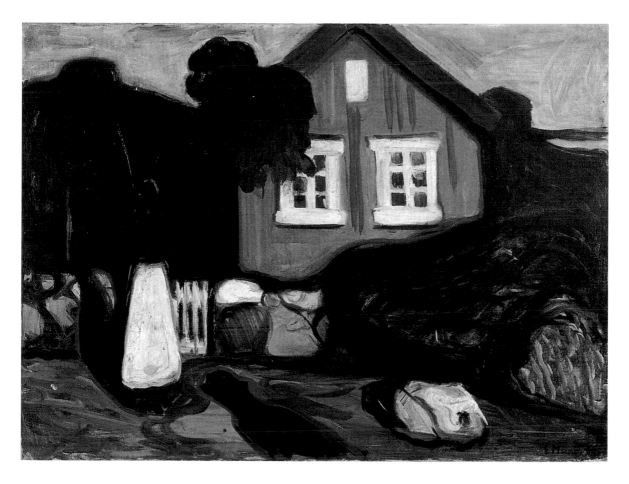

and stands facing us, her hands behind her back, like the woman in *The Voice* (p. 32) (now in Boston). Munch's pictorial space is divided up along strict geometrical lines. The white fence, which reflects the moonlight, runs parallel to the bottom edge and provides a near-symbolic frame for the slightly conical shape of the woman's lower half. This spatial structure is reinforced by the brown wooden wall and the white window frame, and the emphatic horizontals and verticals contrast with the left portion of the painting, where the deep, dark green recedes into the unplumbed depths of night. The large shadow on the wall behind the woman is linked to this dark area. At the right, a few flowers are visible in the darkness; at the left, the red shape of a second figure appears at the edge of the picture. If we compare *House in Moonlight* (p. 37), done in 1895, we find that what was a close-up is now a longer shot. The house in the centre of the painting is now readily identifiable as Munch's little fisherman's cottage at Åsgårdstrand. Again we see a woman standing outside the dark garden, though all we can really make out is the simply-rendered bell-shape of her light skirt. This light area standing

House in Moonlight, 1895
Oil on canvas, 70 × 95.8 cm
Rasmus Meyer Collection, Bergen

out solidly against the dark background makes a second visual highlight to counterpoint the rust-red house with its two white-framed windows. The overall composition is static in character; but two dynamic irruptions introduce an element of unease. One is the wavy thrust of bushes and shrubs sweeping centrewards from the right. The other is the shadow in the foreground, slanting in towards the woman. The shape of the hat suggests that this off-canvas figure is male; but it is impossible to tell whether the moonlit scene is one of arrival or farewell, and this ambiguity lends the painting its curious flavour of mixed expectation and fearful uncertainty.

Stormy Night (p. 39), painted in 1893 and in the Museum of Modern Art (New York) since 1974, is relatively little known in Europe. Like most of Munch's paintings, this one had its distinct starting point in reality, an occasion of an external nature. Jens Thiis, then director of the Oslo National Gallery, left a record of a terrible storm in Åsgårdstrand. As we have seen, Åsgårdstrand was for many years a well-loved, much-frequented retreat of Munch's, and others naturally came too: in the summer holidays the resort attracted a good many families, particularly women and children whose menfolk were at work in Christiania. (The steamer connection was excellent.) In Munch's painting, the stormy weather, the group of women, and Åsgårdstrand itself (with the easily identified Køsterud building, which the artist often featured prominently in his works) all had their real counterparts. But this is no mere naturalism: Munch has transfigured the seen world into a landscape of the soul. The big house with its brightly-lit windows (Munch scratched away the paint around the yellow, to intensify the luminous effect) represents the security the women have quit. They are on their way down to the mole. In the middle distance to the left there is a group of women, dressed in different colours, sketchily established by means of loose brush-strokes, and one woman in white has moved away from the group. Like the other women, she is holding her hands over her ears so as not to hear the howling of the storm. And it is this woman who is at the centre of attention. It is worth asking what all of this adds up to, what it expresses.

Munch has achieved an act of transformation. The dramatic natural event of the storm, the sharp contrast between the bright windows of the house (promising security) and the immeasurable depths of the dark night – in other words, an account of physical actuality – have been refashioned into an image of inner tension and conflict. In covering their ears with their hands, the women are not only shutting out the roaring of the wind and of the sea which is presumably in front of them. Beyond this literal level, they are an image of a society on the point of exploding, a society we see in Ibsen's

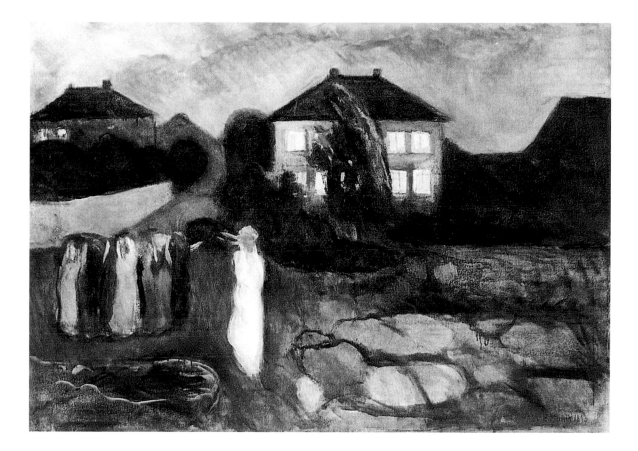

plays, too. The group of women body forth energy of spirit.
The single woman in white is related to the figure (whose sex
cannot be clearly established) in the various versions of *The
Scream* (p. 52); and, beyond that, she re-appears as a central
figure in major works by Munch, such as *The Three Stages of
Woman* (p. 46), *The Dance of Life* (pp. 48/49) and the Rein-
hardt Frieze (pp. 59, 60, 61 and 63).

On that first wall in the 1903 show – 'Love's awakening'
– Munch also exhibited two works that might almost appear
to belong in the next group: *The Kiss* and *Madonna*. Painted
in Oslo in 1897, the version of *The Kiss* (p. 41) now in the
Munch Museum is a distilled and simplified account of an-
other rendering of the same theme which the artist did at the
same time and which is now in the Oslo National Gallery.
The realistic basis was a farewell scene of an autobiographical
character: the room where the man kisses the woman has a
clear similarity to Munch's room in St. Cloud. (The curtains
and the crossbar of the window are familiar from sketches
and from *Night in Saint-Cloud*, p. 19.) The kissing couple,
their two figures merging into one, are seen standing between
a blue curtain (partly drawn back to reveal the yellow light in

Stormy Night, 1893
Oil on canvas, 91.5 × 131 cm
Museum of Modern Art, New York

39

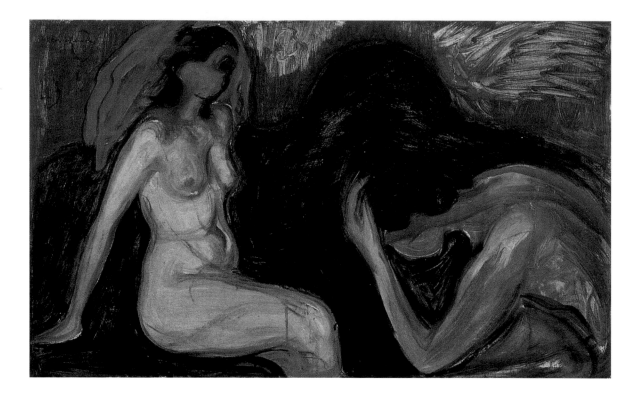

Man and Woman, 1898
Oil on canvas, 60.2 × 100 cm
Rasmus Meyer Collection, Bergen

RIGHT:
The Kiss, 1897
Oil on canvas, 99 × 81 cm
Munch Museum, Oslo

the bright street beyond) and the reddish brown wall on the right. The two bodies are dark, solid, monumental. Stanislaw Przybyszewski, who wrote the first biography of Munch, gave this somewhat poetic description of the scene in 1894: "We see two human figures, each of the two faces melting into the other. Not a single one of their features can be made out: all we see is that point where they melt, a point that looks like a huge ear, rendered deaf by the ecstasy of the blood. It looks like a pool of molten flesh."

The Bergen painting *Man and Woman* (p. 40), done in 1898, is thematically related. Once again Munch is expressing the fateful attraction of the sexes and the threat one's own sexuality can represent. Thus he sets his woman against a massive dark shadow, a shadow which rises menacingly above the man's head. The woman's head and face are framed by a red "halo". The man is seen bending forward, his torso naked, resting his head in melancholy pose in his hand, his arm crooked at the elbow. Munch dispenses with individualization of the woman's facial features, and the man's head is turned away from us, so that (as in *The Kiss*) he is once more making his impact without any psychological analysis.

The 1903 Leipzig exhibition was photographed, and we therefore know that on the next wall, 'Love blossoms and dies', *Madonna* (p. 30) was hung first. However, it is impossi-

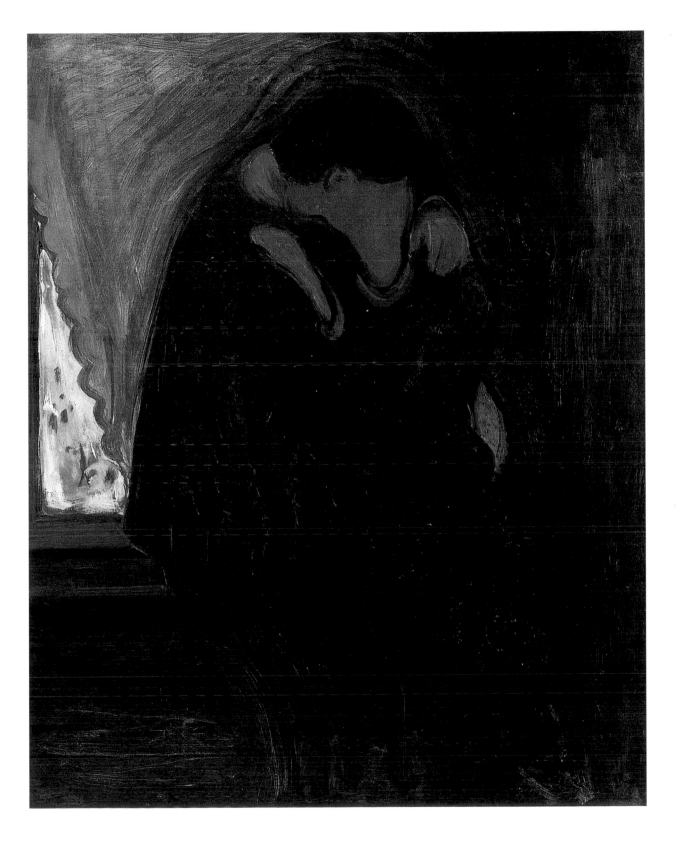

The Day After, 1895
Etching, 19.1 × 27.7 cm

ble to be certain which of the five versions Munch painted of this picture it was. At all events, when the painting was first shown in public in 1893 it had a frame that was decorated with painted or carved sperm or foetuses. This frame was subsequently removed and apparently lost. It invested the female nude with meanings connected with conception (the sperm) and death (the foetuses had death's-heads). What is most striking about the canvas itself, in compositional terms, is that this woman naked to below the waist appears in a curiously suspended, disembodied state. It is not only the broad, flowing, framing brush-strokes that create this impression. The position of her arms – the right held behind her head and disappearing into the flow of colour, the left held behind the waist as if bound there – has the effect of foregrounding her breasts and belly.

In mythological or literary terms, Munch's *Madonna* (or *Loving Woman*, as he also titled the work) occupies an ambiguous middle-ground between Ophelia and Salome. Neither sleeping nor waking, reclining nor standing, rising nor falling, revealing nor concealing, this figure has a bewitching ambiguity which has made it Munch's best-known pictorial image after *The Scream* (p. 52). The upper corners introduce a colour tension that draws its power from the contrast of brown/red and blue/black; but the dominant colour signal in the painting is the bright red halo – little more than a cap – set on the ravenblack hair that falls across the woman's shoulders. Her nipples and navel are highlighted in the same red. This nude seems to be thrusting towards us, majestic and forceful, and the effect is heightened by the geometrical simplification of certain parts of her body (for instance, the ellipses made by the eyes and brows, perhaps as an intentional visual echo of the crescent of the halo). Arne Eggum has even seen in her halo a cognate of the goddess Astarte's crescent moon.

Munch twice wrote of what he saw as the direct link between life and death in this image. (The reference to moonlight may imply that the painter had the version in the Oslo National Gallery in mind, since the gleam of "moonlight" is clearly visible on the forehead, nose, cheeks and chin.) On one occasion he wrote: "All the tenderness in the world is in your face – Moonlight passes across it – Your face is full of the beauty and pain of the world, because [...] Death and Life are joining hands and the chain that links the thousand generations of the dead with the thousand generations yet to be born is connected." And elsewhere:

"That pause when the world stops in its course All the beauty of the globe is in your face Your lips crimson as the fruit that is to come part as if in pain The smile of a corpse Now Life joins hands with Death The chain is connected linking the thousand generations of the dead to the thousand generations yet to be born."

"In reality, my art is a confession made of my own free will, an attempt to clarify my own notion of Life ... at bottom it is a kind of egoism, but I shall not give up hoping that with its assistance I shall be able to help others achieve their own clarity."
EDVARD MUNCH

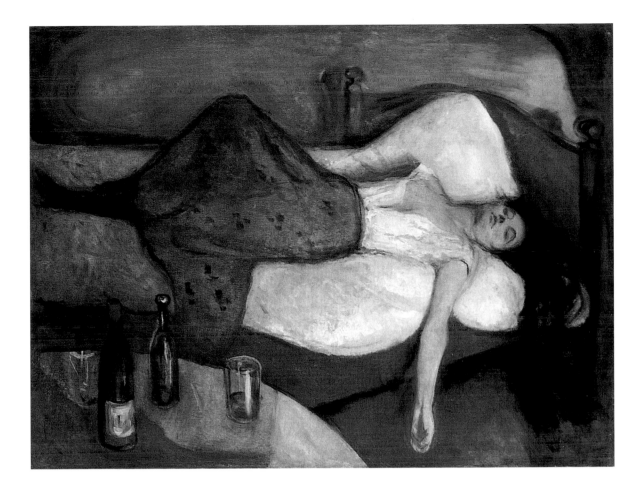

The Day After, 1894/95
Oil on canvas, 115 × 152 cm
National Gallery, Oslo

Closely related to the *Madonna* is a painting with the eloquent title *The Day After* (p. 43). An early version was painted in 1886 but later destroyed; it was exhibited in Berlin in 1892.

At the Leipzig exhibition, the painting Munch hung next to the *Madonna* was one of the most enigmatic in the entire Frieze of Life: *Ashes* (p. 45). The hanging order is still preserved in the central sky-lit hall in the Oslo National Gallery, where *Ashes* hangs between *Madonna* and *The Scream* on the end wall. In this painting, the setting looks more like stage scenery than ever. In the left foreground, a man dressed in black is bending over in a position suggestive of despair, grief or simply melancholy; but the picture is dominated by the woman standing somewhat right of centre, facing us squarely. Her long white petticoat is unbuttoned, revealing a red chemise worn under it. She is holding her hands up to her head, and her long chestnut hair is falling about her body and even reaching out a line whose flowing contour embraces the man's head and back. The woman's face wears a frozen ex-

Self-portrait with Skeleton Arm, 1895
Lithograph, 60 × 20 cm
Munch Museum, Oslo

pression and her eyes are wide open. The setting, rendered in stage-like simplicity, has the appearance of a shoreline by night, with the slender trunks of pine trees framing the woman to right and left where the dark forest begins in the background. The most curious detail in the painting is surely the log which occupies almost the entire baseline of the composition and at the left becomes a column of smoke rising vertically. The log (it seems) is being reduced to ash; though its relevance doubtless goes beyond this literal connection with the title of the work. In compositional terms, the log is the equivalent of the bone at the base of Munch's 1895 lithograph *Self-portrait with Skeleton Arm* (p. 44). And it is also reminiscent of that lost frame of *Madonna*, with its sperm.

Naturally the scene can be interpreted as the breakdown of a love affair, passion slowly being extinguished like the embers of a dying fire. No doubt biographical data can be adduced to support this interpretation, too. However, if we view the painting in these banal terms, the transformation Munch has wrought in his material is all the more impressive. The two people appear before us arrested in eloquent gestures – like actors in Japanese Noh plays, or the magic realms in Shakespeare, or Ibsen's dramas of the soul, or (in our own time) Samuel Beckett's compulsive theatrical rituals. What lends Munch's work its modern character, its peculiarly contemporary relevance, is the difficulty of putting into words the meaning of these people's poses. In this, Munch's paintings resemble Beckett's plays, which reveal their full meanings only in performance, meanings which defy the attempt to pin them down. The mask-like face of the woman, and the turned-away profile of the man, provided Munch with a means of eluding that psychological-cum-biographical style of critical approach which has remained popular to this day. We may note in conclusion that Beckett has invested the image of ashes, in his plays and in his novels, with considerable metaphysical implication.

In a 1985 thesis on Munch's use of trios of women, the scholar Monika Graen identified *The Three Stages of Woman* (p. 46) as the artist's seminal work using this motif. Now in the Rasmus Meyer Collection in Bergen, it was painted around 1894 and first exhibited in that year with the title *Sphinx* in the Stockholm show of his pictures on the theme of love. At the Berlin exhibition in 1902 it was the centre-piece of the 'Love blossoms and dies' sequence. The few preparatory sketches and studies that have been published show that the three women are not intended as portraits of three individual women but rather (as the later title suggests) as a visual rendering of Munch's concepts of different aspects of Woman. At left we see the woman of the sea, of the water, the sea nymph who pays no attention whatever to male courtship. Her flowing hair echoes the flowing contours of the shoreline

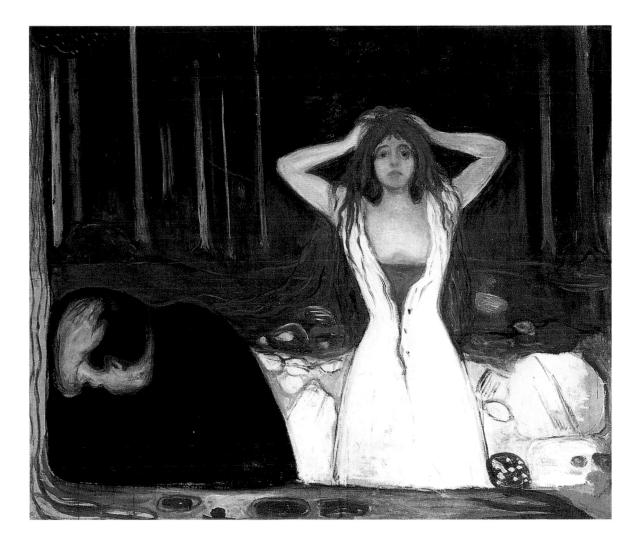

and waves. This type of woman re-appears later in *Separation* and elsewhere. In the middle stands a tall, naked woman, her hands behind her head, legs astride, gazing at us with an almost demoniac grin. There is something genuinely alarming about this woman. Her facial expression is reminiscent of the *Madonna*; but her flame-red hair, her made-up eyebrows and lips, and the way she holds her head, all recall a portrait Munch painted a year earlier, of Dagny Juell (Ducha) Przybyszewski, and Monika Graen has suggested that Munch modelled this woman on Ducha. The third woman is right next to her, but half-enveloped in the darkness of the wood. Both Munch's mournful sister Inger and Milly Thaulow (who appeared in *Moonlight*, p. 36) can be seen in this woman, and these similarities seem confirmed by the long, dark skirt falling to the ground. But of course such resemblances are not as important as what Munch has made of the woman. With her

Ashes, 1894
Oil on canvas, 120.5 × 141 cm
National Gallery, Oslo

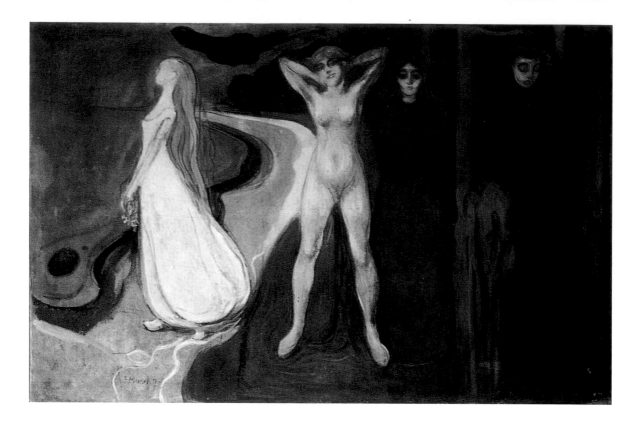

**The Three Stages of Woman (Sphinx),
c. 1894**
Oil on canvas, 164 × 250 cm
Rasmus Meyer Collection, Bergen

eyes deep in shadow, she has something of a corpse, and the
dark line that contours the figure is like the black frame of a
death notice. In the right-hand quarter of the painting (whose
sectional structure is reminiscent of various forerunners,
among them the frescoes Hans von Maree had done twenty
years previously) we see a male figure standing between two
trees. His head is bowed, his features are simplified to the
point of decorative geometricality, and his hair is styled hel-
met-fashion: the same kind of man as in *Melancholy* (p. 47).
The critics have identified these men as being not only por-
traits of Munch's friend Jappe Nilssen but also oblique self-
portraits. In addition to the four figures, we must not over-
look the lily-like flowers the young "virgin" is holding; the
flow of colour (a tree-trunk) pouring down between the naked
woman's legs; and the "blossom of blood" which is assigned
to the man. To judge by the walking position of the man, it
seems he is an outsider turning away from the women.

What Munch himself said by way of explanation has
something of banal rationalization about it, compared with
the painting. His comments seem designed to mask his pro-
found and painful involvement with the subject. Monika
Graen has linked the "flower of pain" to the pietistic Chri-
stianity of Munch's home background. As so often at the turn

of the century, the artist's sufferings were being compared with those of Christ and the painter appeared as a secular Christ figure. Writing on the Frieze of Life, Munch himself said the following of this picture: "... The three women – one of them dressed in white, Irene, dreaming of the life that lies ahead – then the naked one, Maya, full of *joie de vivre* – then the mournful woman with her fixed, pale expression, standing amongst the tree-trunks – the fate of Irene, to nurse the sick. These three women re-appear in Ibsen's plays, in various places, as they do in my frieze."

At the Leipzig exhibition, Munch substituted the thematically related painting *The Dance of Life* (pp. 48/49) for *The Three Stages of Woman*. The smaller painting, done some five years later in 1899/1900, might be seen at first glance as an anecdotal version of *The Three Stages of Woman*. Munch's own description fits in with a superficial interpretation very conveniently: "In the middle the big picture I painted this summer. I was dancing with my first love; it was a memory of her. In comes the smiling woman with her blonde curls, out to pick the blossom of love without being picked herself. On

PAGES 48/49:
The Dance of Life, 1899/1900
Oil on canvas, 125.5 × 190.5 cm
National Gallery, Oslo

Melancholy, 1894/95
Oil on canvas, 81 × 100.5 cm
Rasmus Meyer Collection, Bergen

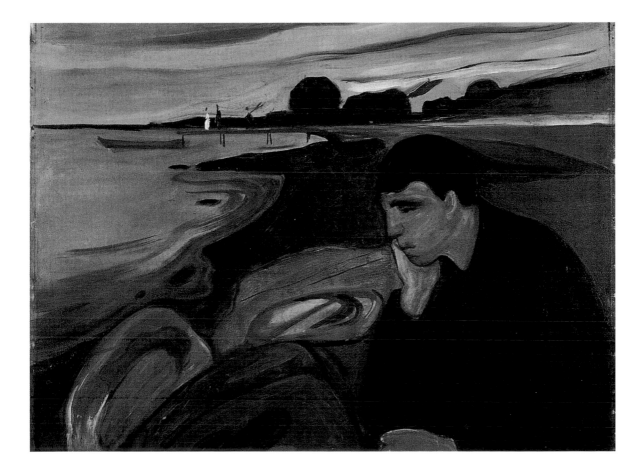

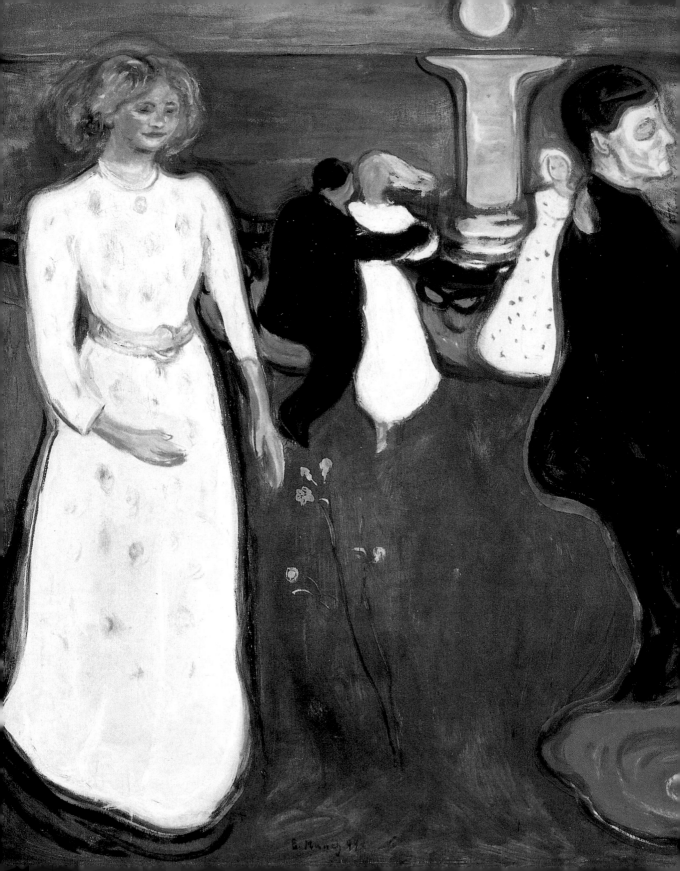

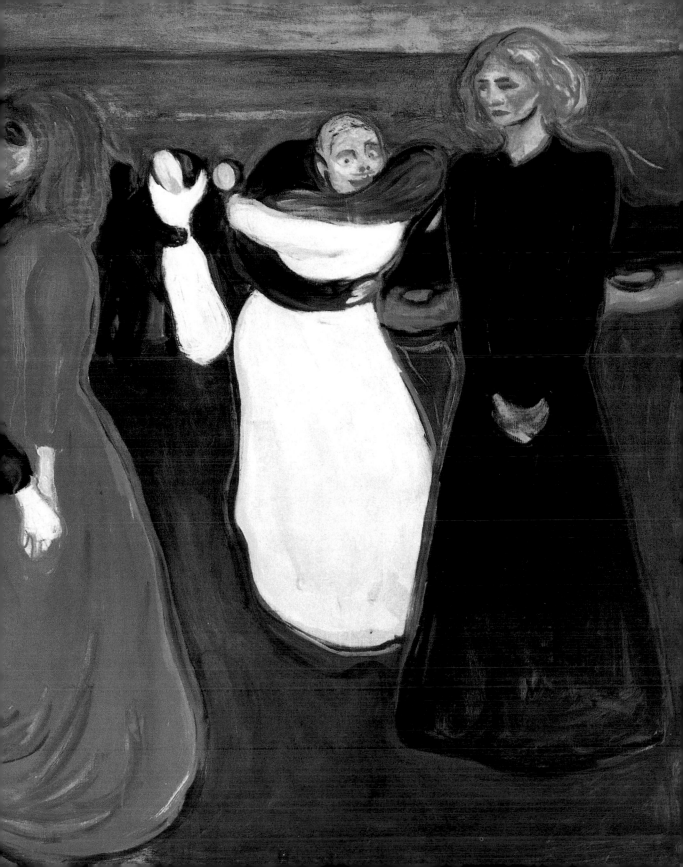

Evening on Karl Johan, 1892
Pencil and black chalk, 37 × 47 cm
Munch Museum, Oslo

the other side stands the woman in black, watching the dancing couple in anguish. She has been excluded, just as I was excluded when they danced..."

Once again, all three women are conceived in relation to Man, his wishes, his experience, his disillusionment. The scene began as a "jolly dance" at Åsgårdstrand. (A grassy space under the trees is still used for dances to this day.) But Munch transformed it into something unsettling and eerie. The four foreground figures are not alone in their dream world; there are a number of other faceless dancing couples, going about their summer night pleasures in wild abandon. One of these people is individualized on the right, a man dancing with a woman dressed in white, his face an Ensor-like mask of delight. In the left half we see Munch's recurring magical symbol, the shaft of moonlight that casts its powerful spell over all.

These factors serve to emphasize the way in which the main group is presented; and a further technique Munch uses for focussing our attention on the foregrounded foursome is the strong juxtaposition of black and red. The man and woman in the middle have their eyes closed, and their faces are so mask-like as to make them appear in a trance. The woman's red dress is wafting to the left as they dance, like a wave catching at the man in black and snatching the ground from under his feet. She also has her right arm about him, and the continuous line from the wave of the dress through that arm binds him firmly to her. The trees that normally appear in works in the Frieze of Life are absent from this painting; but it is nevertheless one of the major works in the sequence.

At this point – midway through the Frieze, as it were – it may be helpful to quote Munch's own view of the sequence once again: "The Frieze of Life is conceived as a series of paintings which together present a picture of life. Through the whole series runs the undulating line of the seashore. Beyond that line is the ever-moving sea, while beneath the trees a life in all its fullness, its variety, its joy and sufferings. The Frieze is a poem of life, love and death. [...] The pictures showing a beach and some trees, in which the same colours keep returning, receive their prevailing tone from the summer night. The trees and the sea provide vertical and horizontal lines which are repeated in all the pictures; the beach and the human figures give the note of luxuriantly pulsing life – and the strong colours bring all the pictures into key with each other..."

As we have seen, 'Love blossoms and dies' concludes with the early, 1891 version of *Melancholy* (reproduced in the present study in the 1894/95 version, cf. p. 47). The painting was also exhibited under the titles *Jappe on the Shore* and *Jealousy*. From here it is but a short step to the third section of the Frieze, 'Fear of Life'. In 1902 the pictures exhibited

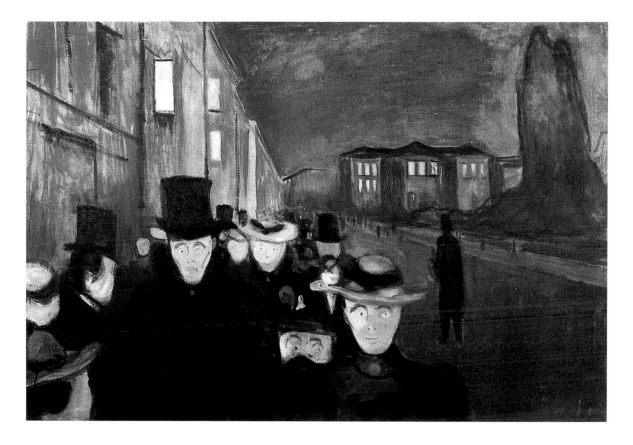

under this title were *Red Clouds, Street* (also titled *Evening on Karl Johan*), *Autumn, The Final Hour* and *Cry of Fear*. In Leipzig in 1903 they were *Virginia Creeper, The Scream, Anxiety* and the 1892 *Evening on Karl Johan*, one of the masterpieces in the Rasmus Meyer Collection in Bergen. Some two years after he painted his impressionist *Spring Day on Karl Johan* (p. 20), Munch once again turned to Christiania's main boulevard as the setting for his drama of loneliness, anxiety and isolation. This time we are looking towards the Stortinget, the Norwegian parliament, built in 1866 in such a way as to mark one end of the avenue as the palace marked the other. Choosing his angle of vision so as to crop the people walking along the pavement at waist or chest height, Munch gives us a sense of the crowd's oppressive proximity. It is a middle-class crowd seen through the eyes of Christiania's bohemia, the men waring top hats and the women elegant bonnets. Though their eyes are open wide, their faces are uncommunicative. Themselves prisoners of middle-class norms and constraints, they are all playing their part in the creation of an atmosphere of moral repression. The parliament building, the seat of law and order, its bright yellow and white windows gleaming like eyes, seems to be keeping watch on the scene,

Evening on Karl Johan, 1892
Oil on canvas, 84.5 × 121 cm
Rasmus Meyer Collection, Bergen

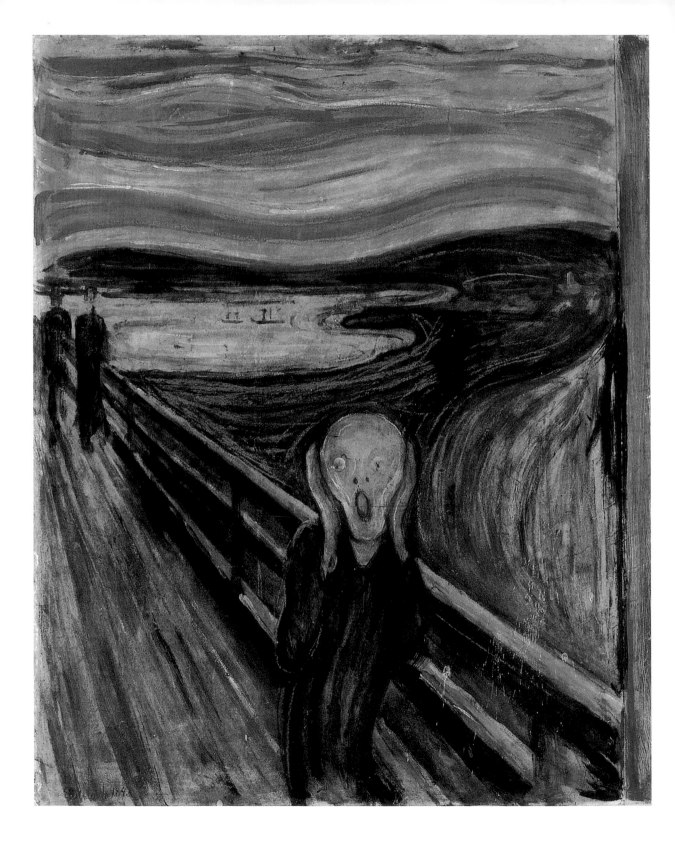

at once a guard and an authority. And then there is one solitary figure out in the street, walking away from us, past the crowd, against the flow. It is not difficult to grasp what this figure represents. Notes in Munch's diary confirm what we already suspect: "The passers-by were all giving him strange and peculiar looks and he could sense them looking at him – staring at him – all those faces – pale in the evening light – he tried to cling to some thought, but failed – he had a sense of there being nothing inside his head but emptiness – and then he tried to fix his gaze on a window far up above – and once again the passers-by got in his way – he was trembling from tip to toe and breaking out in a sweat."

The mask-like faces in the picture have prompted comparison with those in *The Entry of Christ into Brussels* (1888), the masterpiece (now in the Paul Getty Museum, Malibu) of the Belgian artist James Ensor (1860–1942). What is all Munch's own, of course, is his painting technique. His technique is not subordinate to the rigorous compositional structure; rather, it has an independent function of heightening the expressive force of the work. Munch's technique is unique because of its closeness to the principles of abstract art. For example, a closer look at the three windows directly above the skull-like man's top hat reveals that Munch has applied impasto strokes of thick yellow and white oil paint to rectangular areas of the canvas (the grey house wall) that had been left almost entirely bare of paint. These strokes do not convey interior lighting. Rather, they are abstract miniatures in their own right, with a clear affinity to the American abstract expressionism of Barnett Newman, Hans Hofmann and Robert Motherwell around 1950.

In *Evening on Karl Johan*, anxiety and isolation in the crowd and in the city were Munch's subject. In his most famous picture, *The Scream* (p. 52), fifty further versions of which exist in addition to the 1893 painting now in the Oslo National Gallery, we see the fear and loneliness of Man in a natural setting which – far from offering any kind of consolation – picks up the scream and echoes it beyond the bay unto the bloody vaults of heaven. The bay and the small sailing vessels, and the bridge with its railing cutting diagonally across the picture, suggest that the setting was Nordstrand. Munch's diary contains an entry written in Nice during a period of illness in 1892 which recalls this scene: "I was out walking with two friends – the sun began to set – suddenly the sky turned blood-red – I paused, feeling exhausted, and leaned on a fence – there was blood and tongues of fire above the blue-black fjord and the city – my friends walked on, and there I still stood, trembling with fear – and I sensed an endless scream passing through Nature."

The American art historian Robert Rosenblum has proposed that a Peruvian mummy in the Musée de l'Homme in

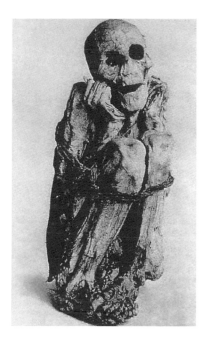

Mummy (Peru)
Musée de l'Homme, Paris

The Scream, 1893
Oil, tempera and pastel on cardboard,
91 × 73.5 cm
National Gallery, Oslo

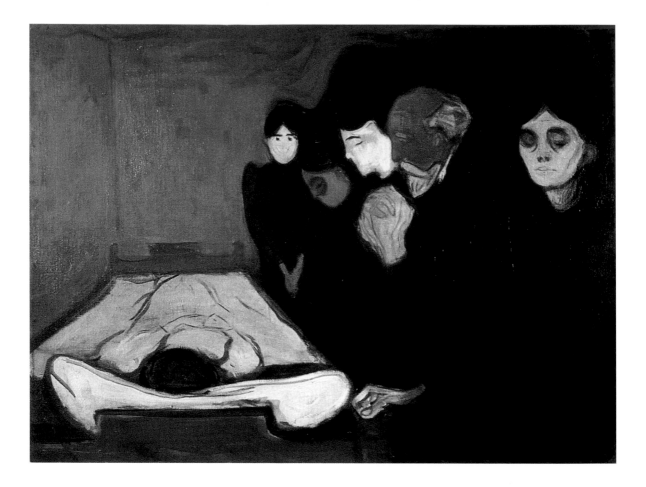

The Death Bed, 1895
Oil on canvas, 90 × 120.5 cm
Rasmus Meyer Collection, Bergen

Paris (p. 53) served Munch as a model for his death's-head. The similarity of the bound-up mummy, holding its hands up to its head like the figure in *The Scream*, is indeed striking. Literary sources, particularly the work of Fyodor Dostoyevsky (a great favourite of Munch's), may be adduced; and this passage from the philosopher Søren Kierkegaard (1813–1855) – whom Munch only read later, but who was surely related to the painter in outlook – is worth quoting: "My soul is so heavy that no thought can uplift it any more, nor any wingbeat bear it aloft into the ether. If anything moves it at all, it merely grazes the ground, like a bird flying low before a storm. Oppressiveness and anxiety are brooding over my inner being, sensing an earthquake to come."

And there is the poet Rainer Maria Rilke (1875–1926), who was asked to write a piece on Oskar Kokoschka in 1920. In his letter of refusal (to Arpad Weingärtner, 12 April 1920) Rilke wrote of the lines in Munch's paintings, and may have had *The Scream* in mind: "Munch's lines already included this constructive power of terror – but there is infinitely more

of Nature in him than in Kokoschka, and so he was always able to reconcile the opposites of preservation and destruction in purely spatial terms, to blunt their edge in an image or picture..."

The final series in the Frieze of Life was devoted to Death. Munch had exhibited some works on this subject – *Death Throes*, *The Death Chamber*, *Death, Life and Death* and *Death and the Child* – in Berlin. A year later in Berlin there were just three pictures: *Death in the Sick Chamber*, *The Death Bed* and *The Dead Mother and the Child*. In *The Death Bed* (p. 54), painted in 1895 and now in Bergen, Munch picks up the subject matter of his early masterpiece *The Sick Child* (p. 11). Now, however, the patient is no longer the focal

Death in the Sick Chamber, 1895
Oil on canvas, 150 × 167.5 cm
National Gallery, Oslo

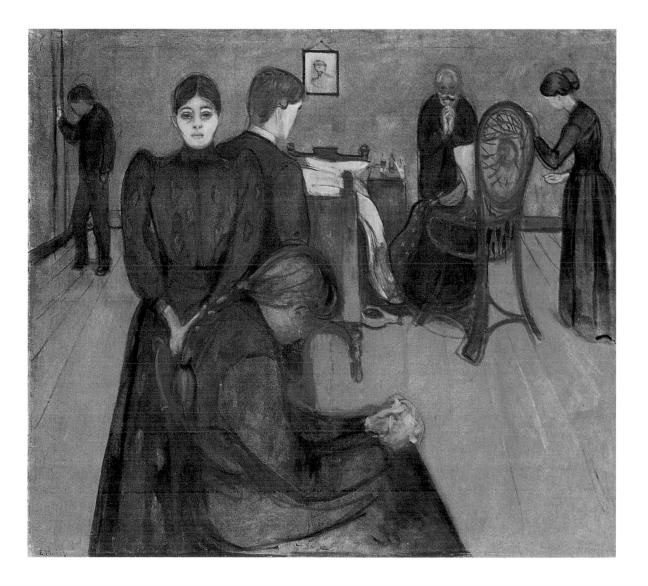

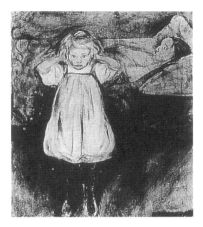

**The Dead Mother and the Child,
1899/1900**
Oil on canvas, 100 × 90 cm
Kunsthalle Bremen, Bremen

point. Instead, our attention is on the heads and hands of the family members at the bedside, highlighted against a massive area of black. And by presenting the sickbed at a flat, foreshortened angle, Munch includes us at the bedside as witnesses of this death. The pallor of the white bed contrasts with the emphatic chestnut shade of the walls; and from the right the dark shadow of Death encroaches, with only the bright faces and hands of the family standing out against the black. The people in the picture are rendered only simply and sketchily and it is hard to identify them – though the father, offering ardent prayers, is unmistakable. The figure beside the father may be the artist himself. We cannont say for sure whether the women are Aunt Karen Bjølstad (who ran the household after Munch's mother died, and was supportive in her encouragement of the young artist) and – in the background – sister Inger or Laura.

Death in the Sick Chamber (p. 55), a larger composition painted about the same time and now in the National Gallery in Oslo, provides an overall impression of the claustrophobic, torturing isolation of the sick room. The high back of the wicker chair blocks our view of the dead person. The two sisters Inger (standing) and Laura (seated) are clearly recognizable. The artist himself is in the background, turned away from the scene. The father and aunt are standing by the armchair. The male figure with his back to us may be brother Andreas.

But what makes Munch's art so essentially distinctive is not his sensitive presentation of important childhood experiences, nor his acute psychological perceptions. Rather, his significance is a matter of radical artistic approach, in terms both of composition and (perhaps even more important) of painting technique. *The Dead Mother and the Child* (p. 57), painted in 1897/99 and now in Oslo's Munch Museum, may serve as an example of this radical approach, together with the later version of 1899/1900 (p. 56) now in the Kunsthalle in Bremen. Again we are in the death chamber. The scene recalls the early death of young Edvard's mother in 1868. Beyond the bed, which is positioned horizontally in the composition, we see five adult members of the family, evidently helpless in the face of death, as we can tell from their nervous gestures and restless movements. But in the foreground, this side of the mother's bed, is young Sophie, then six years old and one year older than Edvard, holding her hands over her ears to block out the silent but painful scream of death. Turning to the Bremen picture, we find a radical simplification of the scene: in vertical format rather than horizontal, this version dispenses with the psychological account of the family's responses to the death, and instead concentrates on the girl, thus becoming a portrait of Munch's sister Sophie. She is seen standing by the prone body of her mother, one vertical along-

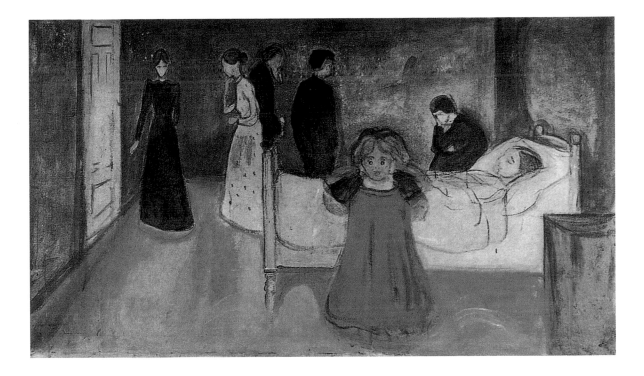

The Dead Mother and the Child, 1897/99
Oil on canvas, 104.5 × 179.5 cm
Munch Museum, Oslo

side one horizontal. The watery oil paint does not entirely cover the bright canvas. The mother's facial features, and those of the child in particular, have been done in oil crayon, and only the white collar framing the girl's chin, and parts of her sleeve, have been fully painted in with oil. The child is standing on a floor whose chestnut shade is all Life, but as our gaze rises towards her head we see that she is half in the dark greenish-blue realm of Death. Life and Death meet in this picture with a starkness scarcely equalled elsewhere.

After Munch's major work, the Frieze of Life, had been seen in Berlin and Leipzig it was also exhibited in Copenhagen, Christiania and finally Prague. The paintings chosen for inclusion varied each time; there was no fixed sequence. At the end of 1903, Dr. Max Linde provided Munch with the first opportunity to try out his frieze in fixed form. Linde, an eye specialist in Lübeck, commissioned a decorative friezc for the spacious room his four sons shared. In 1982 a reconstruction of the series of paintings was published. Apparently it consisted of eleven oils on canvas, the largest 315 cm wide, the smallest only 30 cm wide, and all 90 or 92 cm high. *Summer Day* (p. 58), done in 1904/08 and now in a Norwegian private collection, can be seen (together with *Young People by the Sea* and *Dance by the Sea*) as an adaptation of themes already dealt with in the Frieze of Life. But Munch did not merely re-use his Frieze of Life subjects of love, fear and death. In the Linde Frieze he concentrated on the first part, 'Love's

**Summer Day (from the Linde Frieze),
1904–1908**
Oil on canvas, 90 × 195 cm
Private collection

RIGHT:
**Two Girls (from the Reinhardt Frieze),
1906/07**
Tempera on unprimed canvas,
90 × 70 cm
National Gallery SMPK, Berlin

awakening', especially the landscape motifs. The Frieze was hung in the Lübeck room from December 1904 till April 1905, then put into storage; and finally the eleven pictures ended up in the studio of Munch's friend Leonhardt Boldt in Berlin. Dr. Linde had decided not to keep the Frieze, and instead he bought the big painting *Summer Night (Three Women on the Bridge)*, which is now in the Thielska Gallery in Stockholm. *Summer Day* may be considered representative of the paintings in the Linde Frieze. Munch made a few changes to it after it returned to his keeping. In its present state it was acquired by the Berlin National Gallery in 1930 but was confiscated by the Nazis seven years later on the grounds that it was "degenerate". For a while it was in Hermann Göring's private collection before being returned to Oslo in 1939. To imagine what the picture looked like in its original state we must pretend that the couple embracing, and probably the girl at bottom right looking out of the picture and the conical cluster of girls in the middle, are not there. What remains is a scene of great serenity: a summer day of peaceful pleasure at secluded, sunny Åsgårdstrand. The gentle horizontals of the grass, beach and the deep blue water add up to a perfect natural stage that has no need of human actors. In the centre of the painting is the gleaming yellow-white triangle of a boat's sails, and closer in to shore a rowing boat with people in brightly coloured clothes. Vertical divisions are provided by the trunks of pine trees. Their geometrically-rendered branches are suspended over the water like green sails. In this, Munch plainly followed the terms of his commission, and respected the wish for landscape motifs.

In a letter of 8 August 1904, Linde restated his desire for a frieze suitable for children: "I am very pleased that you have

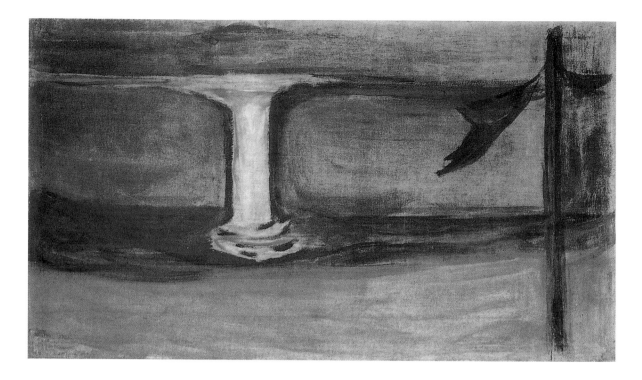

Åsgårdstrand (from the Reinhardt Frieze), 1906/07
Tempera on unprimed canvas,
91 × 157.5 cm
National Gallery SMPK, Berlin

already finished some designs for the children's room. Please choose childlike subjects, by which I mean subjects suitable for children, in other words no lovers kissing and so forth. Children know nothing of such things. I have been thinking that landscape would be best, since landscape is neutral and gives a child pleasure." There is no clear expression of Linde's reasons for finding the Frieze unacceptable. Perhaps he and his wife saw the tense and melancholy mood beneath Munch's bright landscapes and did not care to inflict it on their children.

The major additions, or changes, made by Munch some time between 1905 and 1908 included the transparent couple, the conical group of girls, and probably the girl at bottom right. Arne Eggum has suggested that the transparency of the couple was inspired by the double exposures Munch liked to produce in his photographic work. This couple (above all, the woman's face) introduces a hard quality of tension into the cheerful serenity of the summer scene, a quality which Munch was at liberty to introduce once the picture no longer needed to fulfil a decorative function. The girl at bottom right may have been intended to mitigate the harshness of the first addition. No psychological interpretation of the girl's face is possible, since it consists only of an impasto oval, with no recognizable features.

Munch's next opportunity to transform his Frieze of Life into decoration for a room arose from contact with Max Rein-

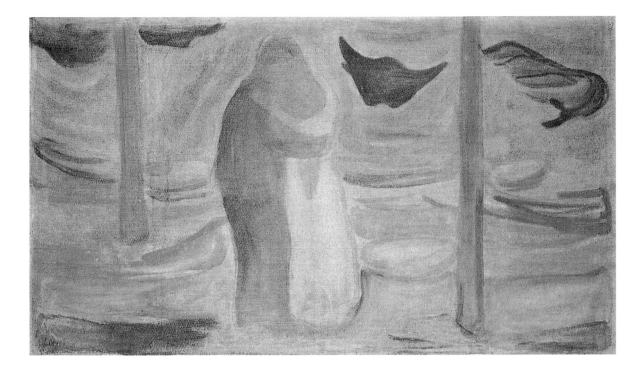

hardt (1873–1943), the great Berlin theatre impresario. Then
artistic director of the Deutsches Theater, Reinhardt was
pushing ahead with plans for a chamber theatre, and in 1906
it was opened with a legendary production of Ibsen's *Ghosts*.
The stage set for that production was designed by Munch,
who had probably been recommended to Reinhardt by Wal-
ther Rathenau and Count Harry Kessler. It was presumably at
the same time that Munch was commissioned to design a
frieze for the little oval hall on the first floor. An exhibition
devoted to the Reinhardt Frieze, seen in Berlin and Kiel in
1978 (catalogue by Peter Krieger), documented the twelve-
part series in detail. The measurements were the same as for
the Linde Frieze; but now Munch was free of the obligation to
paint images suitable for children. On 26 December, 1907,
Munch wrote to his friend Jens Thiis, reporting the comple-
tion of the work with obvious relief: "It has been real torture,
this decorative work for the Berlin Chamber Theatre [...] and
the stupid thing is that the payment is quite out of proportion
to the effort involved [...] it is a frieze, and I have painted it
for one of the main halls – it goes round all four walls, and the
motifs are taken from the beach outside my house at
Åsgårdstrand – men and women in a summer night."

 Munch's most important new departure in this version
of the frieze was a novel technique; he used tempera on un-
primed canvas. It gave a deep, luminous glow to the colours,
so that beneath the matt surface the pictures convey an evo-

**Couple on the Shore (from the Rein-
hardt Frieze), 1906/07**
Tempera on unprimed canvas,
90 × 155 cm
National Gallery SMPK, Berlin

Caspar David Friedrich:
**Man and Woman Contemplating
the Moon, c. 1830–35**
Oil on canvas, 34 × 44 cm
National Gallery SMPK, Berlin

cative impression of the intense light of the Norwegian mid-summer night. The motifs are easy to recognize. *Åsgårdstrand* (p. 60), with its yellow column of moonlight, echoes the 1895 *Moonlight* (p. 33). The *Two Girls* (p. 59) had made their first appearance in 1894 in the Frieze of Life, as the first work in the 'Love's awakening' series, titled *Red and White* (Munch Museum, Oslo). They are the first two stages in *The Three Stages of Woman* (p. 46) and *The Dance of Life* (pp. 48/49). *Couple on the Shore* (p. 61) is reminiscent of *The Kiss* (p. 41) in the earlier frieze.

And then there is *The Lonely Ones* (p. 63), a variation on the well-known theme of Munch's beautiful coloured wood-cut of the same title, done in 1899. The contrast with figures seen from the rear in Caspar David Friedrich's paintings is worth considering. In works by Friedrich such as *Man and Woman Contemplating the Moon* (p. 62) the emphasis is on a religious dimension, and (if we bear in mind the political implications of traditional German costume during the War of Liberation) perhaps a historical dimension too. In Munch, the true subject is erotic tension. The human figures and the landscape all serve the symbolic presentation of natural forces of a sexual character.

The Reinhardt Frieze was hung over the doors and between the windows. Because it was so high up, Munch contoured his people and landscapes with bold, clear brushstrokes so that they would make an impact even when viewed from a distance. Never again was Munch to achieve this beautiful ease of rhythmical movement, the figures placed on their landscape stage with ample free space around them. And for once it is possible to see quite clearly what Munch meant when he later wrote: "Through the whole series runs the undulating line of the seashore. Beyond that line is the ever-moving sea, while beneath the trees is life in all its fullness, its variety, its joys and sufferings."

The Frieze met with a poor response. The oval hall had been intended for use during intervals but in practice was only occasionally used for festivities. In 1912 it was restyled and the pictures were sold through an art dealer, Hugo Perls – and the public had been given no opportunity whatsoever to view the sequence of masterpieces together in their original place. Not until 1966, when the Berlin National Gallery succeeded in acquiring eight pictures, was the series re-established as a single unity again.

The huge murals Munch did for the Great Hall of Christiania University between 1914 and 1916 can be viewed as a continuation of the same work in a different key. Munch himself said: "The Frieze of Life presents a close-up of the sufferings and joys of the individual – the University murals body forth powerful, eternal forces." The eleven massive canvases consist of five pairs of complementary paintings to the

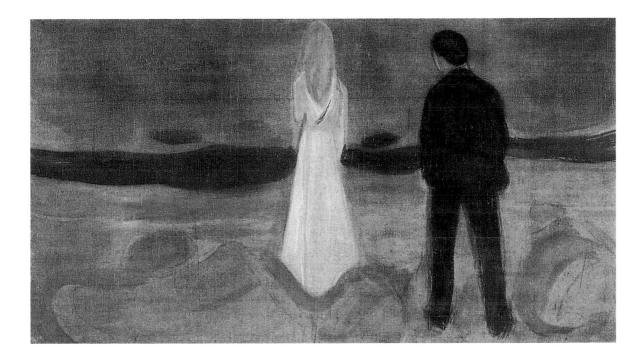

right and left on the long walls of the rectangular hall, above eye-level. On the end wall is *The Sun* (pp. 86/87), a massive canvas showing a huge and radiant sun rising over an idealized version of the Kragerø fjord. The two major works on the side walls are both over eleven metres wide: *Alma mater*, the allegorical figure of a mother with her children, and *History*, which shows an old man telling stories to a boy.

In 1921 Munch was again commissioned to make a frieze, and the following year he painted twelve pictures for the workers' canteen in the Freia chocolate factory in Christiania, drawing on the serene atmosphere of the Linde Frieze. Well into old age, Munch continued to long for rooms to adorn with his frieze. When he was nearly seventy, and already suffering from an eye complaint, he became interested in re-casting his life's great work for the new town hall that was being built in Oslo; but his designs, which he began work on in 1928, came to nothing. At any rate, it would be no exaggeration to add another ten years in Munch's own comment on his Frieze of Life: "With major interruptions, I worked on the Frieze for about thirty years." So central is the Frieze in Munch's work that one might conclude that his art must be understood in terms of context and sequence. But every important work of art transcends the historical moment, the social background, and the formal conditions of its creation; and this is eminently true of Munch's art too. It is the power of individual paintings that gives Munch's work its enduring force.

The Lonely Ones (Summer Night)
(from the Reinhardt Frieze), 1906/07
Tempera on unprimed canvas,
89.5 × 159.5 cm
Folkwang Museum, Essen

Recognition Late in Life:
Portraits, Landscapes and Self-portraits

As we have seen, Munch's career as an artist began with scandals. If we disregard the decorations of the Great Hall in Oslo University, he was unable to realize his overriding ambition to find a permanent home for the Frieze of Life. (In any case, the pictures he painted for the Great Hall were all closely linked to a specific programme in keeping with the academic nature of the location.) Apart from Oslo's Munch Museum, which has a very representative collection, the sky-lit room in the National Gallery to which we have already referred is the only place (partly arranged along the lines of his Ekely studio) where Munch's pictures are loosely grouped as a frieze. The eight parts of the Reinhardt Frieze exhibited in Berlin's National Gallery constitute a third representation where Munch's concept of the frieze could be realized, at least in part.

Munch made his first real breakthrough and scored his first lasting success in Germany, where Expressionism was later to bear its finest fruits. After the turn of the century, Munch found the Germans ready to grant him the recognition he needed. First it came from private collectors such as the eye specialist Dr. Max Linde (1862–1940) to whom we have already referred, judge Gustav Schiefler (1857–1935), art dealer and collector Albert Kollmann (1837–1915) and the writer and politician Count Harry Kessler (1868–1937). Munch painted portraits of all these men, and – as was his habit – did several versions of them. The German breakthrough was also assisted by the efforts of two major galleries (Cassirer and Commeter) which signed up Munch contractually. Munch began exhibiting at the Paul Cassirer Gallery in Berlin in 1901 and at the Commeter Gallery in Hamburg in 1903. The *Sonderbund* exhibition in Cologne in 1912 gave Munch a room to himself, where thirtytwo paintings were on display, which placed him on an equal footing with Van Gogh, Cézanne, Gauguin and Picasso and attracted international attention to his art. Occasionally museums or major private collections (such as that of Karl Ernst Osthaus in Hagen, which later provided the core of the Folkwang Museum in Essen) bought pictures by Munch before the First World

"I was on the brink of insanity – it was touch and go . . ." EDVARD MUNCH

Self-portrait: Between Clock and Bed, 1940/42
Oil on canvas, 149.5 × 120.5 cm
Munch Museum, Oslo

War. On the whole, though, the leading German museums began buying Munch after 1920, when the artist was almost sixty. When in 1925 financial difficulties obliged Dr. Max Linde to sell his impressive collection of contemporary art (by Böcklin, Thoma, Leibl, Manet, Monet, Degas, Signac, Rodin and Munch), German museums bought up most of his Munchs, and Linde noted in a letter to the painter that "the time has now come, dear Herr Munch, when the museums are ready for your work, though distinctly *post festum*, I must say".

The National Gallery in Oslo possessed an important Munch collection at a relatively early date, largely because of the major works donated in 1909/10 by Olaf Schou. Germany's museums followed in the mid-1920s, with Switzerland next, some five years later. Wilhelm Wartmann, director of the Zurich Kunsthaus, tried tirelessly to persuade backers to put up the money for paintings by Munch. Today, the Zurich Munch holdings are the most important in central Europe. In Germany, museum acquisitions were helped by the personal commitment to modern art, both German and international, of a number of museum directors. Max Sauerlandt, then director of the Hamburg Museum of Arts and Crafts, told a German Museum Association conference in 1929: "To have contemporary art in our galleries strikes me as an absolute must, not merely for its own sake, or for the sake of the artists, but also in order to assess the art of the past in the right perspective."

Throughout the decade that had elapsed since the First World War, German museums had systematically been integrating international contemporary art into their collections; and, alongside the leading French painters, Munch was the most important artist they were buying. Ludwig Justi, director of the National Gallery in Berlin, summed up the significance Munch had for Germany in a retrospective statement made in 1930: "Of all the great foreign painters, Edvard Munch has arguably made the most considerable impact on modern German art." The inclusion of his paintings in permanent collections throughout Germany (until the Nazis threw German cultural policy into reverse) also underlines a vital function Munch's art had during the 1920s: as a mediator between German and French art.

Around the turn of the century the theme of the different ages in Life began to acquire greater importance in Munch's art. People in his work are always both individuals and generalized types: their distinctive features are scrupulously observed and their faces, figures and bearing recognizably rendered, but his composition, brushwork and colour usage add a dimension of the distilled and typical.

Four Ages in Life (p. 67), painted in 1902 and now in the Rasmus Meyer Collection in Bergen, shows three women and

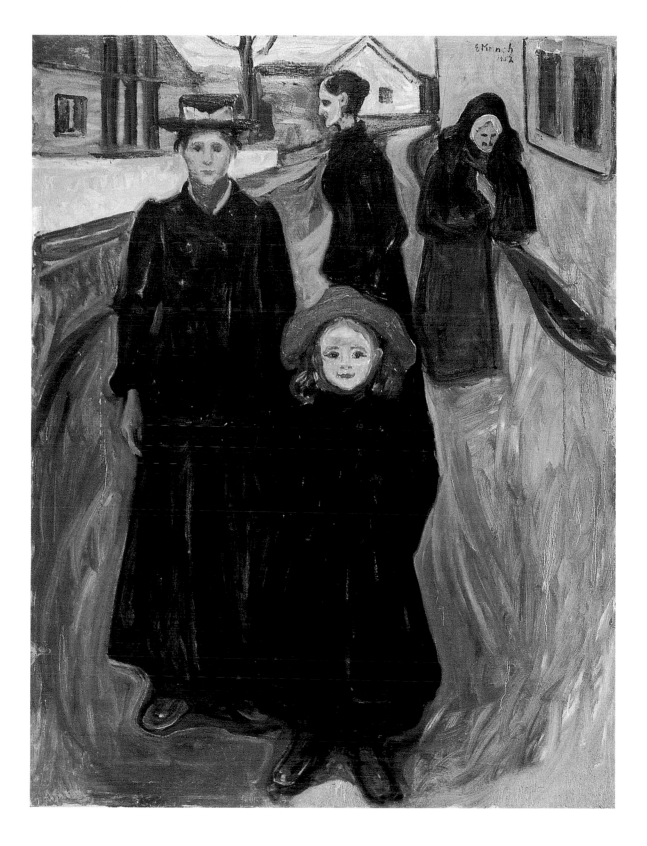

Poster for Peer Gynt, 1896
Lithograph, 25 × 29.8 cm

a girl in the village street at Åsgårdstrand – a street which we may interpret symbolically as the path of Life. The little girl wearing a big red hat is right up front, with a facial expression that is not as sad as in the solo portrait *Girl in a Red Hat* in Wuppertal, but (in respect of her frontal stance) clearly linked to the girl in *The Dead Mother and the Child* (p. 56). Behind her to the left is the young woman, wearing an elegant hat; right behind the girl, half hidden from view, is an old and careworn woman with dark hollows round her eyes and bony features, seen in profile; and finally, further back still, by the yellow house wall at the right of the picture, there is a grey-haired crone bending at her work. The four figures may be unrelated, given their positions, but Munch has used the sweeping chestnut brush-strokes of the roadway to model them into a group. Their clothing marks the girl and the crone out from the other two women, and they seem the least worried of the group.

The subject of those two women – mother and daughter – had been occupying Munch since 1896 at the latest, when he designed a production of Ibsen's *Peer Gynt* for the Théâtre de l'Oeuvre in Paris (then an avant-garde theatre). In the large-format 1897 painting *Mother and Daughter* (p. 69) we see Munch's sister Inger and his Aunt Karen Bjølstad, positioned in front of a green sloping landscape which cannot be definitely identified. The only props in this scene are the orange-coloured house at left and the golden full moon in the centre; nothing else distracts our attention from the mute colloquy of young Solveig and old Mother Åse from *Peer Gynt*. The thinned paint, and the energetic brush-strokes for which Munch has used his arm as well as wrist, particularly towards the right of the painting, are the main factors in bringing this scene alive.

The non-specific, near-abstract landscape in fact emphasizes the isolation of these women, and the solidity of their painted presence, of their bodies, their dresses. A red and blue line marks off the older woman's dark dress from the many-coloured white shimmer of Inger's. Munch created that shimmering effect by applying colours first, before the white. The landscape and the figures, the body language (standing and sitting) and the colours (blue-white and reddish black) establish the dominant tones that give this double portrait its special resonance.

Two years later, in 1899, Munch painted the first of a total of twelve variants of *Girls on the Bridge*. The first version shows three young women turned away from us and looking over the railing of the jetty at Åsgåstrand into the dark waters. Munch included one of his favourite motifs in this picture: a roadway receding into the remotest reaches in the depths of the painting. The diagonal from bottom left to top right is also a riposte to the right-to-left diagonal in *The*

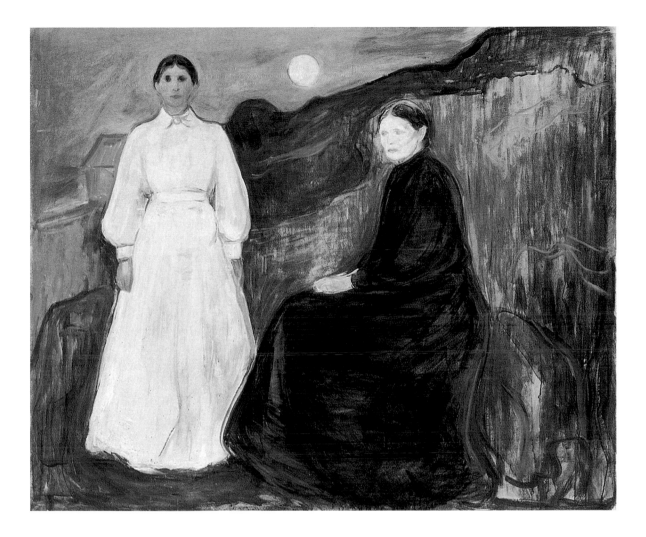

Scream (p. 52). The lines of the jetty that narrow towards the
road at the top right, and of course the railing itself, draw us
persuasively into the depths of the pictorial space, yet these
lines have none of the dynamic violence of those in *The
Scream*. The structural impact is doubly mitigated by the
immense tree beside the Køsterud building, and its black sha-
dow in the waters of the Christiania fjord, which between
them fill most of the left side of the painting. On the whole
the mood is light, thanks especially to the three girls' bright
dresses; but the ominous, dark, menacing reflection in the
water has the effect of muting this lightness. The dark sha-
dow of the tree seems to hold the same kind of magical attrac-
tion for the girls as the column of moonlight has elsewhere.
In compositional terms the tree and its shadow are certainly
there to balance the girls.
 As so often, Munch's distinctive strength consists in his

Mother and Daughter, 1897
Oil on canvas, 135 × 163 cm
National Gallery, Oslo

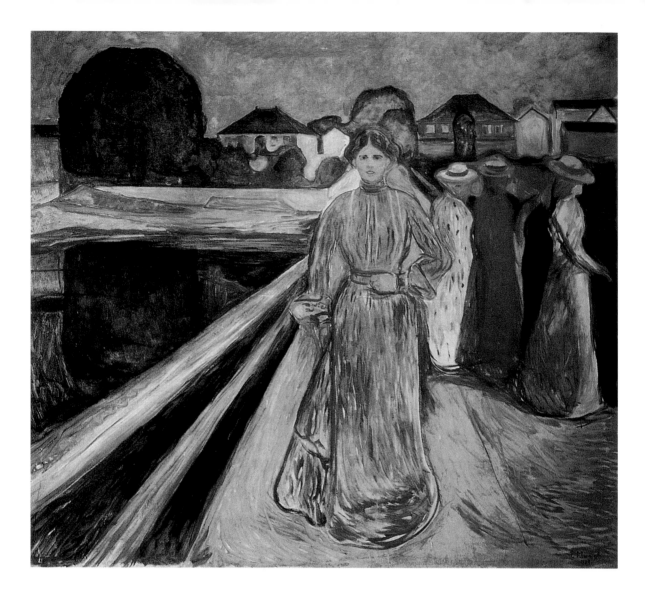

Women on the Bridge, 1902
Oil on canvas, 184 × 205 cm
Billedgalleri, Bergen

departures from the real scene. The subject is drawn from
everyday life in Åsgårdstrand: the girls are waiting for the
young men they are going out with, or perhaps they are young
wives waiting for their husbands to return on the steamer.
The wall and white fence round the Køsterud building premi-
ses has been simplified as a containing line of colour. The
moon is visible beyond the mighty tree but there is no reflec-
tion in the water – the shaft of moonlight has been super-
seded here by the tree's shadow reflection.

Women on the Bridge (p. 70), another version painted
three years later in 1902, is much brighter in colour than the
first. There is no moon, and apparently the scene is daylight
rather than a summer night. The jetty now occupies the

centre of the composition, and the pull into the spatial distance is barred by the young woman in the blue dress coming towards us. In painting this woman, Munch was probably remembering Åse Nørregård, a girlfriend of his youth. The motif of a group of women and one single woman separated from them is familiar to us from *Stormy Night* (p. 39). But now there is a contrast to the 1893 work: in *Women on the Bridge* there is next to no fear of menace at all. Discussing the more cheerful versions of this picture (such as this Bergen version, or that in the Thielska Gallery in Stockholm), Guido Magnaguagno has suggested that Munch was moving away from his subject and indulging in painting for its own sake. If such was the case, though, it was plainly only a temporary shift of priorities and must be seen in relative terms. What matters more for our present purposes is the remarkable in-

Street in Åsgårdstrand, 1902
Oil on canvas, 74.5 × 89 cm
Rasmus Meyer Collection, Bergen

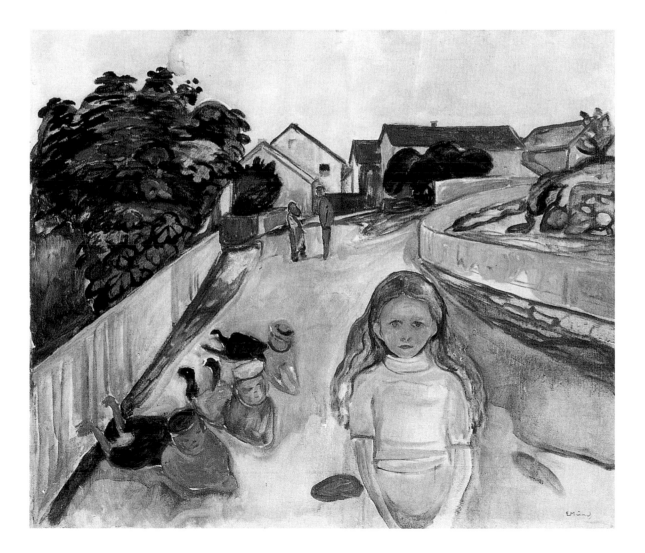

Ducks and Turkeys, 1913
Oil on canvas, 80 × 100 cm
Rolf Stenersen Collection, Bergen

terplay of two types of composition: a solo portrait of an identifiable woman, and a structure in which one woman quits the group and walks towards us. In the Stockholm version, Munch added three men leaning on the railing as a counterpart to the pyramidal group of women. That is to say: even in the lighter versions, Munch remained true to his main thematic concerns, concerns which were intimately related to the Frieze of Life and which for convenience we may label "the ages of Life" or "relations between Man and Woman".

Munch's conceptual world also included the "innocent" world of childhood. *Street in Åsgårdstrand* (p. 71), painted in 1891 and now in Bergen, shows a village street with light-coloured fences running along it. Two people are having a neighbourly chat in the background. Up front, though, seen in challenging close-up, is a little girl, fixing a blue-eyed, frightened, reproachful gaze on us. The three boys lying in the road behind her, starring at her, may have something to do with her state. The boys are lying flat on their bellies, legs in the air, and their position is suggestive of uninhibited lack of restraint. As a group, a group of males, they can pressurize the girl and at the very least embarrass her.

Munch's characteristic view of the relations of the sexes is also expressed in *The Village Street* (p. 73), painted in 1905/08. Munch spent the winter of 1905/06 in Bad Ilmenau and nearby Bad Elgersburg in Germany, convalescing in the northern woods of Thuringia from recent ailments and the hectic city life of Berlin. He wrote to his Aunt Karen Bjølstad that he wanted to test the effect "of country air on my nerves". While there he painted landscapes such as *Thaw at Elgersburg*, designs for the set of Ibsen's *Ghosts*, portraits and self-portraits, and *The Village Street* (now in the Munch Museum in Oslo). To the left we see a tight formation of schoolboys out on the white snow in the village square, while in the background, by way of counterpoint, there is a group of girls under a tree. One girl dressed in red has ventured forward a little. Compositionally speaking, the red of her dress balances out the blue-black of the cluster of boys. That red, the yellow of the ducks at bottom right, the red of the drakes' bills, and the bright blue patches of sky, all provide notes of colour that introduce an element of cheerfulness into the overall mood. Much later, Munch sketched in the bluish outline of a youth seen from the rear at the right-hand edge. Like the single figure in *Evening on Karl Johan* (p. 51), this youth is moving in the opposite direction to the others in the main group. Thus a German village becomes the setting for the drama of individual versus group, of boys and girls imprisoned in their sexual roles. And even "innocent" creatures such as the ducks in the foreground are included in the interplay of tensions and polarities. Seen in this context, *Ducks and Turkeys*

(p. 72), a 1913 picture now in the Rolf Stenersen Collection in
Bergen, acquires its full meaning.

Even in works of an anecdotal or genre nature, Munch's
people are transformed into figures expressive of his view of
life. As we have seen, the painter arrived in Lübeck in De-
cember 1904 to instal his frieze in Dr. Linde's children's
room. In a letter of 9 December 1904 to his patron Albert
Kollmann, Munch wrote: "The frieze is here, and temporarily
hung in position. The frieze is good and the parts go well
together – but it is very powerful, perhaps too powerful and
overwhelming for a fairly small room with delicate white

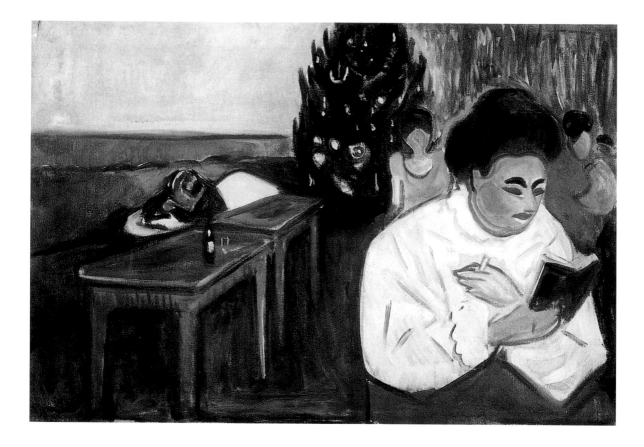

Christmas in the Brothel, 1904/05
Oil on canvas, 60 × 88 cm
Munch Museum, Oslo

Empire furniture..." While he was there he was commissioned to paint the portrait of Senator Holthusen of Hamburg, Dr. Linde's father-in-law. It seems likely that Munch spent most of December in Dr. Linde's home. At first things went well and Munch's work progressed, but around Christmas there were apparently disagreements, disagreements which prompted nervous disorders which Munch tried to subdue with alcohol. The Hamburg commission was cancelled. It seems clear that Munch went to a brothel in Lübeck at this time, and one result was *Christmas in the Brothel* (p. 74), painted in 1904/05. The mood of this colourful picture is light yet melancholy: an idyll unsettled by irony, as it were. The girls have decorated the Christmas tree, put on their best clothes, and are sitting around cosily, reading and smoking. It may not be too fanciful to see this ironic, sentimentally unholy version of the Holy Night of Christmas as Munch's answer to his own pietistic home background as well as to the "delicate white Empire furniture" of Dr. Linde's patrician household.

Another genre scene is the 1913 *Girl Yawning* (p. 75). A naked woman is sitting on the edge of her red bed, about to get up. Her mouth is wide open, yawning, and an interesting

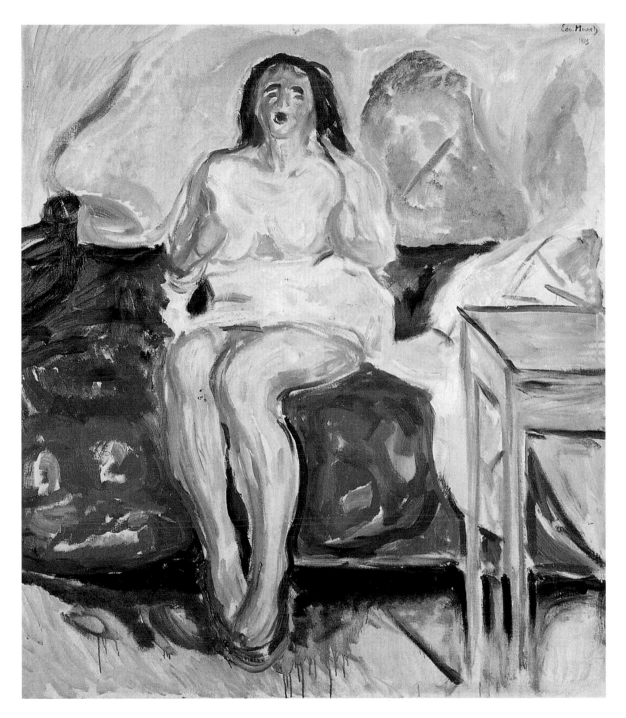

observation by Theodor W. Adorno comes to mind: "When Man yawns, the abyss within is opened wide." The left gesture may be made to warm the foot, but it is also a subconscious reflex. The situation as a whole is reminiscent of that in *Puberty* (p. 35). There is a distinct difference, though: nearly

Girl Yawning, 1913
Oil on canvas, 110 × 100 cm
Rolf Stenersen Collection, Bergen

Two Girls in Blue Smocks, 1904/05
Oil on canvas, 115 × 93 cm
Munch Museum, Oslo

twenty years later, the fear that was expressed symbolically in the huge shadow behind the young girl has now been replaced by a relaxed mood of physical ease. There is nothing threatening about the shadow in this picture. In nudes of this period, the dominant note is generally one of jolly sensuality resulting above all from the wild use of colour. Arne Eggum and Jürgen Schultze have suggested that this aspect of Munch indicates an affinity with the Fauves, and particularly with Henri Matisse. The turbulent colours in *Girl Yawning* are kept in check by Munch's sternly-disciplined compositional structure, though: as always, his structural sense provides an element of stability to hold the image together. As so often, the compositional fundament is the meeting of a horizontal (the bed, cropped at left and right) and a vertical (the woman herself, sitting slightly left of the centre axis).

Munch echoed this structural principle in the self-portraits he painted in 1918 and 1919. In *Self-portrait after Spanish Influenza* (p. 91), for instance, we see him convalescing after a severe illness, raised to an upright position after the horizontal helplessness of the sick bed. These paintings are marked by a note of tension and isolation. This puts the cheerful tone of *Girl Yawning* into a new perspective, of course. And the *Girl Crying*, another nude done about the same time and now in Hamburg, clarifies that borderline that his portraits of women so often are poised on. A woman yawning can rapidly become a woman screaming: the step is a short one. As for the table at right, quite apart from its compositional function of reinforcing the vertical axis it is readily recognizable as a prop we have previously seen in the sick chamber in *The Sick Child*. Munch's visual language survives changes of subject matter and links paintings of considerable diversity in an *oeuvre* of great originality and unity.

There is no unambiguous transition from the presentation of non-individual groups using models or (as in *Women on the Bridge*) simply any women to the portrait proper. At times, indeed, it has taken research or sheer chance to put names to figures that lack definable identities. Thus, for example, Karin von Maur succeeded in naming the *Four Girls at Åsgårdstrand* (p. 77) in the picture painted in 1902 and now in Stuttgart. According to Odd and Mosse Åsen of Åsgårdstrand, they were the four daughters of Hans and Olefine Bugge: Anna, Ruth, Hjørdis and Edle. The Stuttgart catalogue describes the scene in plausible terms: "From his front door, Munch saw the four girls out walking one day in their Sunday best. He stopped them, asked them to stay standing where they were and not move, and painted them." They were local children, not city vacationers, and so they were shy about the strange gentleman, Mr. Munch the painter, and kept at a reserved distance. Munch's painting takes the naturalistic or

impressionistic occasion and transforms the children into images of Life itself. Peter Krieger has described this metamorphosis of the real in persuasive terms: "He stands the four village girls in an orderly group in front of the dirty yellow wall of a house. The painting is done in dark, dirty colours which not only suggests a gloomy, overcast day in early spring but also reveals the spiritual condition of these children. There is as leaden a sadness in their heavy grey-black coats and dresses as there is in the earthy brownish yellow of their faces, which match the shade of the plank wall." The structural exactness that is so typical of Munch is again visible in the broad horizontal of the yellow wall and the four verticals (the girls) at right angles to it. The bold contour lines round the girls' figures, and the jagged shape of the headwear (like mortarboards) worn by the two eldest, serve to emphasize the isolation of these children. All wear an expression of defenceless submissiveness, and that feeling consolidates the unity of the group in the teeth of the isolation we have spoken of. This first version has a greater firmness than two later ones in the Munch Museum.

One year later, as a kind of counterpart, Munch painted

Four Girls at Åsgårdstrand, 1902
Oil on canvas, 89.5 × 125.5 cm
Staatsgalerie Stuttgart, Stuttgart

The Four Sons of Dr. Linde, 1903
Oil on canvas, 144 × 199.5 cm
Art and Cultural History Museum, Lübeck

RIGHT:
Walther Rathenau, 1907
Oil on canvas, 220 × 110 cm
Rasmus Meyer Collection, Bergen

The Four Sons of Dr. Linde (p. 78). Carl Georg Heise (1890–1979), sometimes director of the Lübeck Museum, was responsible for the acquisition of the painting from Dr. Max Linde in 1926, and in a monograph on Munch published in 1956 he reported Dr. Linde's account of the circumstances in which this group portrait came to be painted: "The children were called in from the park, where they were playing, to welcome the foreign visitor. Inquisitive, yet somewhat shy, they stood in front of the white double doors of the garden room, and instantly the artist decided he would set them down on canvas exactly as he had first encountered them." Once again we note Munch's predilection for a stage-like space in which to arrange his figures. The psychological and sociological differences between the boys and the girls from Åsgårdstrand are easy to see. Whereas the village girls make a stiff, imprisoned impression in their Sunday best, the Linde boys are more relaxed and self-assured. The variation in their stances has an ease that matches the sophisticated, indeed

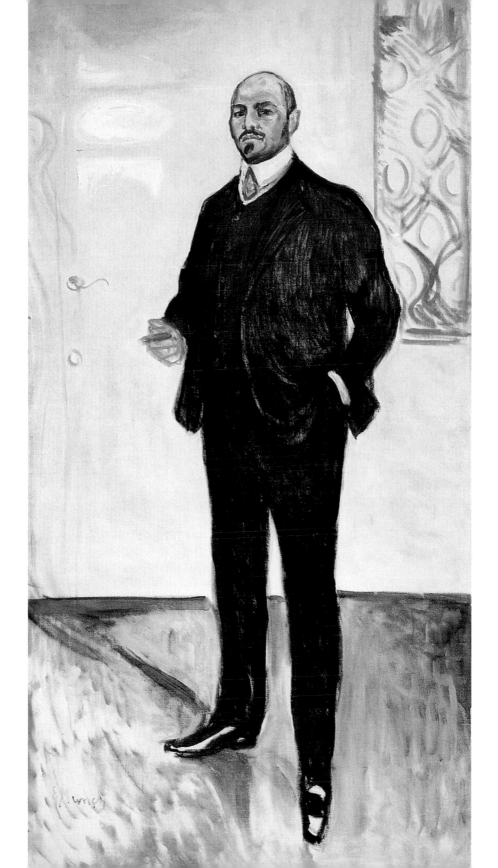

daring composition. On the left, the eldest brother and the youngest (in sailor's uniform) form a small group, while on the right one boy is separate from the rest, plainly the most independent of them, legs astride, holding a straw hat with a yellow ribbon. Max Linde's third son, hands folded in front of him, is in the very centre. The imbalanced positioning of the boys gives liveliness to the composition. The firm stance of the lad with the straw hat contrasts with the delicate, dreamy attitude of the boy leaning against the door-jamb at left. The golden gleam of the parquet flooring, and the white of the double doors and of the garden room's wall panelling, contribute to a light and festive mood. Munch's large-format painting of the four boys called in from play is surely (as Heise put it) "the most significant group portrait of the century", and indeed quite simply one of the loveliest childhood pictures of our times.

Portrait painting was central to Munch's art throughout his life. We have already seen two near-lifesize pictures, the 1885 *Portrait of the Painter Jensen-Hjell* (p. 15) and the 1892 *Sister Inger* (p. 25). Those early works initiated a long series of large-format, full-length portraits of friends, occasionally relatives, and subjects who commissioned the paintings.

At the beginning of the new century, Munch painted numerous portraits of men, most of them friends and patrons. In 1907 his friend Albert Kollmann secured him the commission to paint what was in a sense his most important portrait, that of Walther Rathenau (p. 79). Rathenau (1867–1922) was a German industrial magnate and politician, and was one of the first in Germany to buy Munch's work. As early as 1893 he bought his first Munch, *Rainy Day in Christiania*. On 15 January, 1907, Rathenau wrote to the painter: "Dear Herr Munch, if you are free we can make a start the day after tomorrow, on Thursday, at one o'clock, in Victoriastrasse. I am free for only half an hour on Thursday, but for the subsequent sessions I shall have an hour. Doubtless you will be needing a large canvas; I think I am over six feet tall." Gustav Hillard the director has left us an arresting account (in his memoirs) of one such session in Victoriastrasse, apparently the last: "... Rathenau stands drawn up to his full height, legs apart, his head arrogantly back, his gaze aloofly authoritative, his big feet in narrow, shiny patent leather shoes that stab sharply into the eye. After a while, Rathenau says: 'An awful character, isn't he? That's what you get for having your portrait done by a great artist – you look more like yourself than you really are.'" Hillard probably saw the version that is now in the Märkisches Museum in East Berlin; in the present study the reproduction shows the second, decorative version now in the Rasmus Meyer Collection in Bergen.

Those who commissioned portraits were not always happy with the results. The story of *Woman in Blue (Frau*

Woman in Blue (Frau Barth), 1921
Oil on canvas, 130 × 100 cm
Private collection

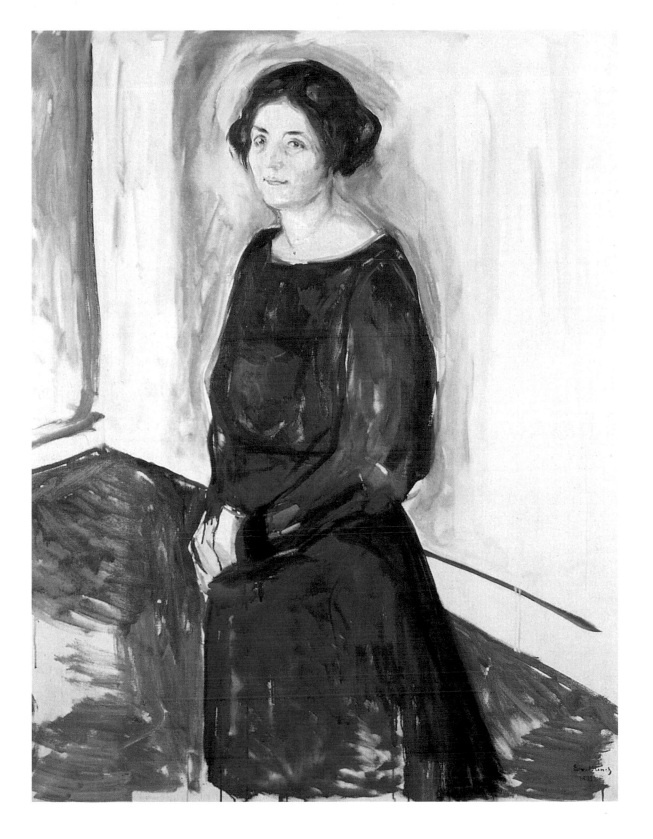

Birgitte Prestoe, c. 1930
Watercolour, 34.8 × 24.7 cm
Munch Museum, Oslo

Woman on the Verandah, 1924
Oil on canvas, 90 × 68 cm
Private collection

Barth) (p. 81) illustrates the point nicely. It is a near-lifesize, three-quarter length portrait of Inger Desideria Barth (1885–1950), the wife of Dr. Peter Barth, a friend of Munch's. It was painted in 1921, and is surely one of the artist's most striking portraits. Fundamentally it is of course conventional in its faithful rendering of a likeness and its approach to the figure as a whole; but Munch achieves a radical concision of insight that goes far beyond a mere image of a middle class lady. The blue in the painting is not merely the colour of a dress, it indicates a condition of the mind and spirit, and Munch emphasizes this by introducing the same blue into Frau Barth's hair. The blue dress is set on a red field, both colours applied in broad, rapid, sketchy brush-strokes. At left, the red area moves through brown to green: this is the floor of the room, though Munch does little more than sketch in his spatial framework. The left-hand wall picks up a blue-green shade from the floor, while the wall that provides the background for the figure is done in subtle blue, green and yellow tones. The tension in this picture comes from the spatial economy, the contrastive colouring, and the sketchy rendering of the figure and the room. Perhaps Frau Barth's unhappy expression, or the sketchiness of the painting, left the couple dissatisfied. Whatever the reason, having commissioned the portrait they preferred not to keep it. At first it was in the Kunsthalle in Hamburg; then, a victim of the Nazis' abhorrence of "degenerate" art, it was removed and sold to a private collector in Norway.

Sketches for paintings were immensely important to Munch. He would often paint sketches onto canvas and then sign them to show that they were considered finished in their own right. One good example of this is *The Nurse*, probably painted during the artist's stay in Dr. Jacobson's clinic in Copenhagen. It was painted in 1909 and is in the Rasmus Meyer Collection in Bergen.

Let us look at one more portrait: the 1924 *Woman on the Verandah* (p. 83). The woman is Brigitte Prestoe, a model Munch used on various occasions. The perspective of the verandah of Munch's house at Ekely is dramatically foreshortened, and the resulting effect of being drawn into a spatial depth, together with the positioning of the woman in her dressing-gown, are compositionally reminiscent of the structure of *The Scream* (p. 52) and perhaps even more strongly of *Girls on the Bridge*. The pull is somewhat neutralized, though, by the vertical of the doorjamb (at right) which the woman is standing by; and both the door and the window opened onto the garden suggest release and escape from the confined atmosphere of the interior. Munch achieves an idiosyncratic balance of colours – an energetic sandy brown and chestnut brown along with the dominant shades of blue – to underpin the dramatic quality of the composition. From the

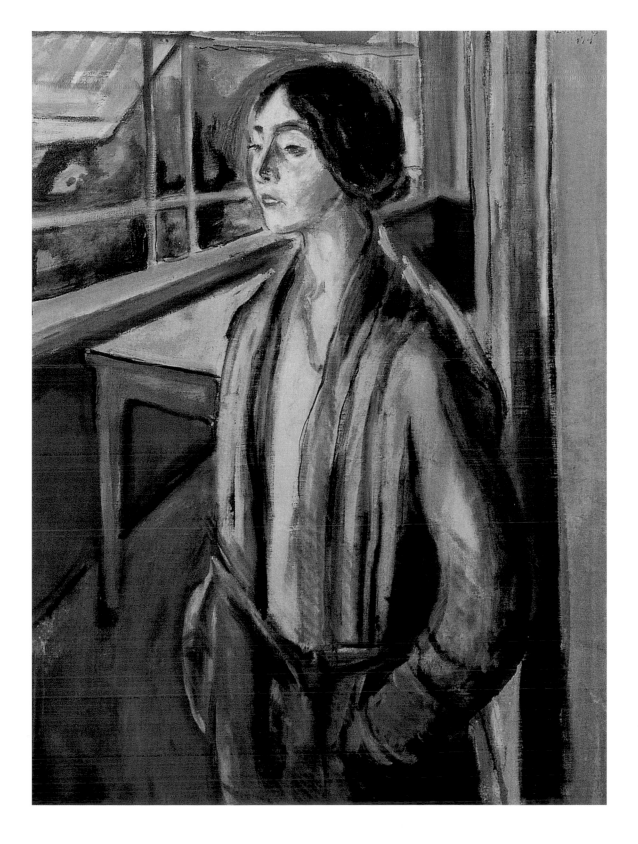

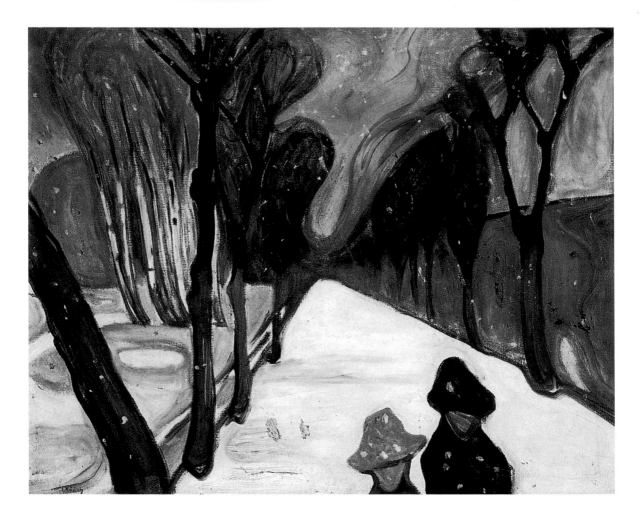

Snow Falling in the Lane, 1906
Oil on canvas, 80 × 100 cm
Munch Museum, Oslo

very start till his old age, Munch also painted landscapes. But pure landscape for its own sake is of very little importance in Munch's *oeuvre*. Munch was no landscape painter. That said, though, it must be added that his most important work (the Frieze of Life) is inconceivable without its Åsgårdstrand landscape. Munch's distinctive achievement lay in an emphasis on a humanized landscape in terms that were uniquely his: *The Scream* is the most familiar example of this. The figure and the landscape become one, the impact of each intensified by the other, in a composition of compelling power. That interaction was Munch's artistic priority.

Two paintings – the 1906 *Snow Falling in the Lane* (p. 84) and the 1919 *The Murderer in the Lane* (p. 85) – persuasively exemplify Munch's ability to unite landscape and figures into a new unity that was characteristic of his art, indeed the very hallmark of his endeavour. The figures in these paintings are two heavily-cropped children and a sketchily rendered murderer. For Munch, landscape always had to convey a message

The Murderer in the Lane, 1919
Oil on canvas, 110 × 138 cm
Munch Museum, Oslo

of human import: his visual idiom transformed the reproduction of landscape scenes into landscapes of the soul.

Munch was very fond of photography and dabbled in experimental camera work a good deal. Perhaps because of this, his sense of the difference between photography and painting was acute: "The camera cannot compete with the painter as long as it cannot be used in Heaven or Hell."

Heaven and Hell were all too familiar to Munch. His whole life long he was forever journeying from one to the other. The details of Munch's landscapes – trees, snow-covered hills, beaches or waves (cf. p. 89) – whether in Kragerø (p. 88), Nordstrand (p. 22), Åsgårdstrand or Hvitsten, were never merely naturalistic reproduction. They were also symbols expressing a personal language of the soul.

Munch also painted self-portraits from the outset. Merciless, exacting, questioning, they accompanied every stage of his artistic life, right until (literally) the very end. These works are not only psychological, sociological and biographi-

PAGES 86/87:
The Sun, 1909–1911
Oil on canvas, 452.4 × 788.5 cm
Munch Museum, Oslo

cal records. They can also bear comparison with the very finest of Munch's achievements.

Since Rembrandt at the very latest, the self-portrait appears to have spurred artists on to work of a very high quality. Self-portraits by Van Gogh, Ferdinand Hodler and Max Beckmann (for instance) are indisputably amongst the major works of these artists. In them we see the artists assessing their own creative endeavours and thus the very premises of their lives.

Winter, Kragerø, 1912
Oil on canvas, 131.5 × 131 cm
Munch Museum, Oslo

We have already discussed Munch's 1895 *Self-portrait with Burning Cigarette* (p. 6) and the step forward that painting represented, beyond the Norwegian artistic climate and the Christiania bohemian milieu of the time. At the same period he painted another picture with the eloquent title *Self-portrait in Hell*. The next significant phase in Munch's self-portraiture spanned the years from 1902 to 1906 and included fourteen works in all. The best known of these is the 1906 *Self-portrait with Wine Bottle* (p. 90). This canvas was painted in Weimar using a photograph taken of the artist in Åsgårdstrand in 1904. The alarming perspective draws us rapidly into the spatial depths, and in the foreground sits Munch himself, between two rows of tables. Apart from the painter, the restaurant is almost deserted: there is a sketchily rendered old woman in the background, and two waiters whose presence has a ghostly quality. Though the colours are

The Wave, 1921
Oil on canvas, 100 × 120 cm
Munch Museum, Oslo

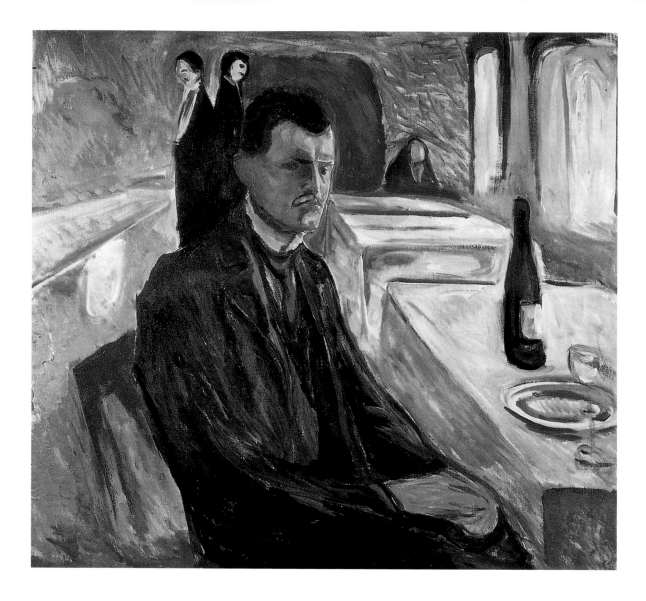

Self-portrait with Wine Bottle, 1906
Oil on canvas, 110.5 × 120.5 cm
Munch Museum, Oslo

alive with forceful contrasts, the overall impression remains one of profound resignation.

Later self-portraits show Munch coming through serious bouts of illness (*Self-portrait after Spanish Influenza*, 1919, p. 91) or overcoming profound doubts (*Self-portrait (in distress)* 1919, p. 92). These pictures dispense entirely with heroic poses, and are done in colours of considerable beauty.

In 1926 Munch painted the *Self-portrait at Ekely* which appears as the frontispiece of this book and which was in the Mannheim Art Gallery until its removal. Munch's face bears witness to the tense concentration of artistic work. We see the strenuous effort involved in painting. Then in 1940, four years before he died a peaceful death at his home at Ekely, at

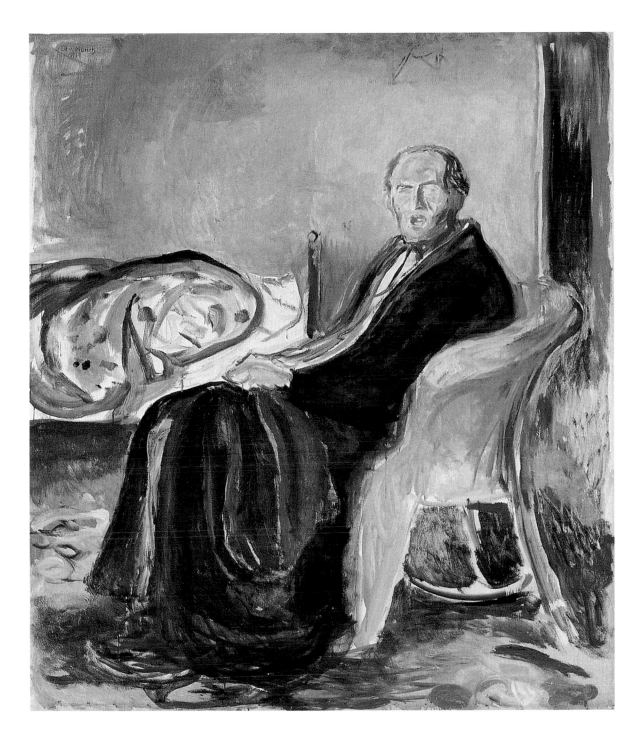

the age of eighty-one, Munch painted a number of self-por-
traits that show him on the borderline of Life and Death. He
continued work on two late masterpieces until the year of his
death: the large vertical-format *Self-portrait: Between Clock*

**Self-portrait after Spanish Influenza,
1919**
Oil on canvas, 150.5 × 131 cm
National Gallery, Oslo

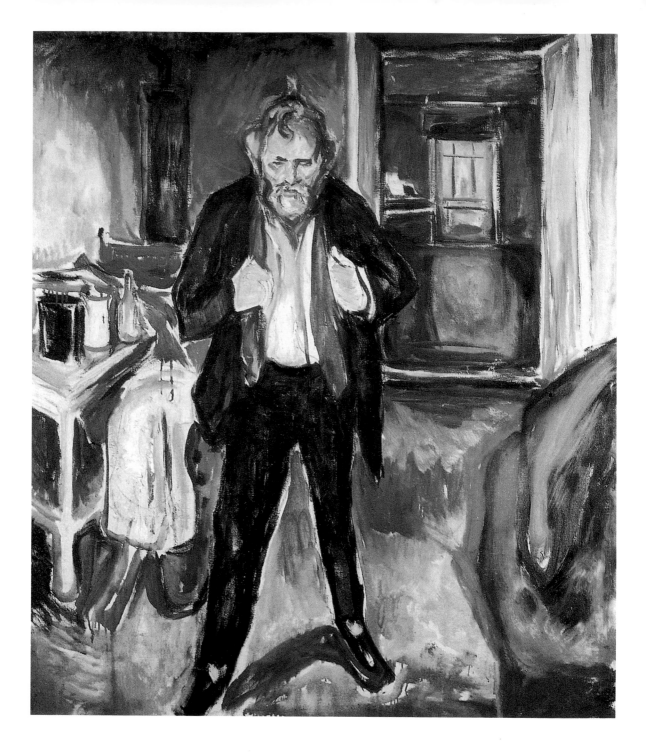

Self-portrait (in distress), 1919
Oil on canvas, 151 × 130 cm
Munch Museum, Oslo

and Bed (p. 64) and the somewhat smaller horizontal-format
By the Window (p. 93). In this last painting, the polarity of
Life and Death has produced a work of striking power. The

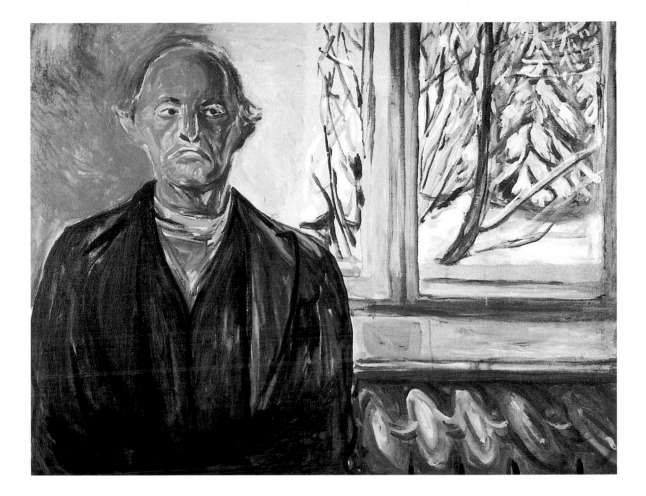

By the Window, 1940
Oil on canvas, 84 × 107.5 cm
Munch Museum, Oslo

strong red of the face and background, with the weighty blue-green of his clothing, establishes a solid zone of Life which is emphatically counterpointed with the realm of Death visible outside the window, where ice and snow hold Nature tight in a frozen grip. The vertical structure of the picture reminds us of the contrast between standing and lying. Life represents a temporary victory over the force of gravity and over matter: we stand, upright, but one day we must lie down, to die. Life is an image of victory. And this late painting reconciles Life and Death, the vertical and the horizontal, movement and stasis.

The editor and publishers should like to thank the museums, collectors, photographers and archives who gave permission to reproduce material. Picture credits: National Gallery, Oslo; Munch Museum, Oslo; Rasmus Meyer Collection, Bergen; Rolf Stenersen Collection, Bergen; O. Vaering, Oslo; Bildarchiv Preussischer Kulturbesitz, Berlin; Folkwang Museum, Essen; Walther & Walther Verlag, Alling.

Edvard Munch 1863–1944

A Chronology

1863 Edvard Munch is born on 12 December in Løten (Norway), second son of Dr. Christian Munch and his wife Laura Cathrine. He has three sisters (Sophie, Laura, Inger) and one brother (Andreas).

1864 The family moves to Christiania (now called Oslo).

1868 Munch's mother dies of tuberculosis. Her sister, Karen Bjølstad, takes over the management of the household.

1877 Sophie dies of tuberculosis, aged fifteen.

1879 Starts studying engineering.

1880 Quits his studies and decides to be a painter.

1881 Studies art. Attends Oslo drawing academy from August, sells two pictures, and paints his first self-portrait.

Munch aged two, 1865

1882 Rents an Oslo studio with six other art students. Christian Krohg supervises their work.

1883 Shows at the Oslo Autumn Exhibition for the first time (from now on he does so regularly). Visits Frits Thaulow's *plein air* academy in Modum.

1884 Contact with Christiania's artistic and literary Bohemia: Jaeger, Krohg, Jensen-Hjell. Meets Milly Thaulow. First scholarship. Revisits Modum in autumn.

1885 Shows at the Antwerp World Exhibition. Paris: studies at the *Salon* and the Louvre. Munch is impressed by Manet. Summer at Borre, autumn in Oslo. Begins three major works: *The Sick Child* (p. 11), *The Day After* (p. 43), *Puberty* (p. 35).

1886 *The Sick Child* scandalizes the public at the Oslo Autumn Exhibition.

Munch's mother with her five children, 1868. Edvard is at right back.

1889 His first solo exhibition in Oslo (110 works) excites interest in some quarters. Summer at Åsgårdstrand, where he spends the summers from now on. State scholarship. Paris: attends Léon Bonnat's art school. Munch's father dies in November. Moves to St. Cloud, a Paris suburb, and relinquishes Naturalism in his St. Cloud manifesto.

1890 At Bonnat's art school. Back in Oslo in May. Paints *Spring Day on Karl Johan* (p. 20) in neo-Impressionist style. Summer in Åsgårdstrand and Oslo. Second state scholarship. To Le Havre in November, where he spends two months in hospital.

1891 To Nice in January and Paris in April, where he lives in the Rue Lafayette (cf. p. 21). Back to Oslo at the end of May. Third state scholarship. Autumn in Nice, working on the Frieze of Life.

Self-portrait, 1881/82 Munch Museum, Oslo

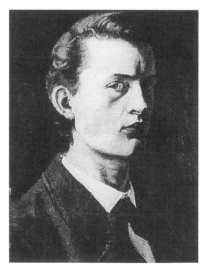

Tulla Larsen and Munch, 1899

Munch in Dr. Max Linde's garden, Lübeck 1902

an edition of Baudelaire's *Les Fleurs du Mal*. His exhibition at the Salon de l'Art Nouveau is reviewed by Strindberg.

1897 In Paris again. Exhibits at the Salon des Indépendants. Buys a house at Åsgårdstrand in the summer. An exhibition in Oslo (85 paintings) is well received.

1898 To Copenhagen, Berlin, Paris. Salon des Indépendants. Illustrations for a special Munch/Strindberg number of the magazine *Quickborn*. Summer at Åsgårdstrand. Meets Tulla Larsen.

1899 Berlin, Paris, Nice, then Florence and Rome, where he studies

1892 Returns home in spring and spends summer at Åsgårdstrand. Stops showing at Oslo Autumn Exhibition. Exhibits in Berlin but meets with a horrified, antagonistic reception from the press and public; the show is closed after one week.

1893 Contact with the Black Piglet literary circle in Berlin: Strindberg, Meier-Graefe, Przybyszewski. Exhibits in Copenhagen, Dresden, Munich, Berlin. Hard at work on the Frieze of Life. Paints *The Scream* (p. 52).

1894 Berlin: first etchings. To Oslo in May. First monograph on Munch is published. Continues Frieze of Life: *Ashes* (p. 45), *The Three Stages of Woman (Sphinx)* (p. 46), *Madonna* (p. 30). Exhibits in Stockholm and Berlin. First lithographs.

1895 Visits Paris twice. Influenced by Toulouse-Lautrec, Bonnard, Vuillard. Edition of eight etchings. Summer at Nordstrand and Åsgårdstrand. Munch's brother Andreas dies.

1896 Spring in Paris. Woodcuts and coloured lithographs printed for the first time. Exhibits at the Salon des Indépendants. Illustrates programme for Ibsen's *Peer Gynt* and

Munch on the beach at Warnemünde, 1907

Raphael. Summer at Nordstrand and Åsgårdstrand. First version of *Girls on the Bridge*. Exhibits at Venice Biennale and in Dresden. Autumn and winter in the Gudbrandsdalen.

1900 To Berlin in March, thence to a Swiss sanatorium. Completes the Frieze of Life.

1901 Paints landscapes at Nordstrand in winter.

1902 Winter and spring in Berlin. Exhibits the completed Frieze of Life at Berlin Sezession. Meets the collector Dr. Max Linde, author of a study of Munch. Makes a dramatic attempt to separate from Tulla Lar-

sen in Åsgårdstrand. First photographic work. Ends the year in Berlin. Gustav Schiefler starts cataloguing Munch's graphic work.

1903 First exhibition at Cassirer Gallery, Berlin. Linde commissions frieze for his boys's room at home in Lübeck. Then Oslo, and Berlin again.

1904 Cassirer (Berlin) acquires sole German rights in Munch's graphic works, Commeter (Hamburg) in his paintings. Numerous exhibitions follow. Member of Berlin Sezession. Exhibits 20 paintings at Vienna Sezession. Salon des Indépendants, Paris. The Weimar Art Academy places a studio at his disposal. Summer at Åsgårdstrand. Exhibits in Copenhagen. November in Lübeck: Linde turns down the frieze.

1905 Exhibits portraits at Cassirer Gallery. Show of 75 paintings in Prague, including the first Frieze of Life sequence. Winter at Bad Ilmenau and Bad Elgersburg (Germany) to calm his nerves and combat his drinking.

1906 Winter to summer in Thuringia and Weimar. Designs set for Ibsen's *Ghosts* and *Hedda Gabler* for Max Reinhardt's Chamber Theatre in Berlin. A frieze is commissioned

for the oval hall in the Chamber Theatre.

1907 Finishes the Reinhardt Frieze, but it remains inaccessible to the public and the pictures are later sold. April in Stockholm, summer and autumn in Warnemünde. Exhibits at Cassirer Gallery with Cézanne and Matisse. Meets Emil Nolde.

1908 Winter in Berlin, spring and summer in Warnemünde. Åse Nørregård dies. Exhibits with the Brücke in Dresden. In the autumn he has a nervous breakdown in Copenhagen. Spends half a year in a clinic. Made a knight of the Royal Norwegian Order of St. Olav.

1909 Returns to Norway in May and rents a house at Kragerø. To Bergen in June, where Rasmus Meyer buys a large number of paintings. Begins work on the murals for the Great Hall of Oslo University.

1910 Buys an estate at Hvitsten on the Oslo fjord. Works on the murals. Major exhibition in Oslo.

1912 Sonderbund exhibition in Cologne, where he shows 32 paintings and is ranked with Van Gogh, Gauguin and Cézanne.

1913 Rents Grimsrød estate on the island of Jeløya on the Oslo fjord. Travels to Berlin, Frankfurt, Cologne, Paris, London, Stockholm, Hamburg, Lübeck, Copenhagen. Tributes on his 50th birthday.

1914 Winter in Berlin and Paris, summer at Hvitsten, Kragerø and Jeløya. After lengthy controversy the Great Hall murals are accepted.

1916 Buys Ekely estate near Oslo.

1918 Publishes his pamphlet: *Frieze of Life*.

1920–21 To Berlin, Paris, Wiesbaden and Frankfurt.

1922 12-painting frieze for the workers' canteen in the Freia chocolate factory, Oslo. Major exhibition in Zurich. Supports German artists by buying 73 graphic works.

1923 Member of German Academy of Fine Arts.

1926 Travels to exhibitions in Munich, Dresden, Copenhagen, Mannheim and Zurich. Munch's sister Laura dies.

1927 Major retrospectives in the Berlin and Oslo National Galleries.

1928 Designs murals for Oslo town hall.

1930 An eye complaint makes work increasingly difficult.

1933 Summer at Åsgårdstrand. Winter at Hvitsten and Kragerø. Tributes on his 70th birthday. Publication of monographs on Munch by Jens Thiis and Pola Gauguin.

1936 First exhibition in England. His eye trouble leads him to stop work on the town hall mural designs.

1937 The Nazis label 82 of Munch's works in German museums "degenerate", and remove and sell them.

1940 German invasion of Norway. Munch refuses to have anything to do with the occupation forces.

1942 First exhibition in the USA

1943 Tributes on his 80th birthday. Serious cold.

1944 Munch dies peacefully at Ekely on 23 January. He leaves his estate to the city of Oslo, which opens the Munch Museum in 1963 to mark the centenary of his birth.

Munch with *The Sun*, 1911

Munch in 1912

Munch at Ekely on his 75th birthday in 1938